Quick and Easy
CREATIVE ART LESSONS

Quick and Easy
CREATIVE ART LESSONS

Anne Martin

Parker Publishing Company, Inc.
West Nyack, NY

Library of Congress Cataloging in Publication Data
Martin, Anne
 Quick and easy creative art lessons.

 Includes index.
 1. Handicraft—Study and teaching. I. Title.
TT168.M33 702' .8 80-17558
ISBN 0-13-749663-x

Printed in the United States of America

Introduction

This book is designed to enrich the child through creative experiences resulting in displayable material which will evoke a positive visual response. It is meant to help the busy teacher who wants fresh art projects each year which can be easily executed in a relatively short time and are also unusually attractive.

These lessons are all one-of-a-kind originals. Each is presented in an organized format of procedures which are known to work. The systems have evolved from seventeen years' experience of teaching hundreds of art lessons to several thousand children. All steps are carefully explained so that the teacher will feel confident about presenting them and will experience a smooth success during the process. Photographs are provided to help define the projects: they are intended to stimulate the teacher's own creativity and generate inspiration for inventing art lessons of her own.

The materials needed are not expensive and can be found among the standard stock in all elementary schools. Substituting alternative materials is occasionally suggested. This might actually have an enhancing effect upon the project—the reader should feel encouraged to experiment.

Above all, the total setting should be viewed as one of helping the child do the best he can and helping him recognize and maintain those standards. This is the most important reason for displaying students' products as attractively as possible. When they see their work shown in a complimentary arrangement, it becomes an endorsement of their efforts, and they will respond with an inner pride which stimulates development of the highest human qualities.

All projects were developed and successfully tested at the Covington Elementary School in Oak Lawn, Illinois for the benefit of teachers and their students everywhere.

Anne Martin

CONTENTS

Chapter 6 Showy Hall Displays (continued)

Quick and Easy CREATIVE ART LESSONS

CHAPTER

1

LIKEABLE PEOPLE

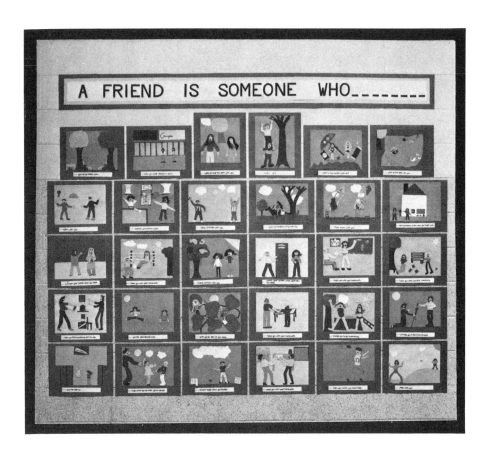

LESSON 1

Friendship Pictures

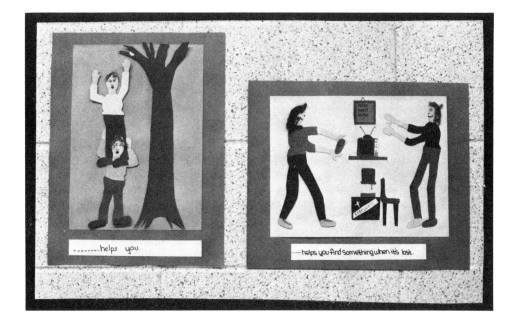

........helps you.

---helps you find something when it's lost.

Whenever your class needs to develop positive social thoughts, this project would be most appropriate. It is especially good at the beginning of the school year when there are often several "new" children who need to establish friendships.

PREPARATION Make a long, narrow, slogan-type sign that states (in cut-paper capital letters): A FRIEND IS SOMEONE WHO ... This banner will serve the dual purpose of helping to motivate your class and later to title the finished display. To make the sign, cut a 12" x 18" piece of white paper into three strips 4" x 18" each. Glue them together end to end to make a band about 4 feet long.

It's easier to cut the letters from rectangles of uniform size. That way, you won't have to draw them first, which saves time in the process. Make the rectangles from a 9" x 12" piece of black construction paper. Divide it first by folding four times across and four times down, or if a paper cutter is handy use that to make sixteen rectangles, 2¼" x 3" each. (You'll need to cut three additional rectangles from another piece of black paper because there will be a final total of nineteen letters.)

Cutting letters isn't as difficult as you may have thought. Most letters of the alphabet are symmetrical either horizontally or vertically. When the prepared rectangles have been folded appropriately, visualize half of each letter with its middle on the fold. Four quick strokes of (very sharp) scissors will complete each of the following letters (see Figure 1-1a):

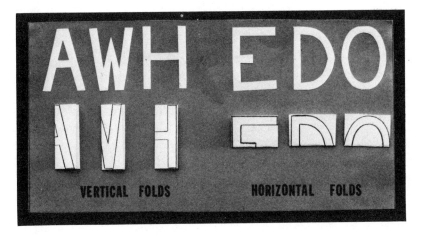

FIGURE 1-1a

The remaining letters are cut without folding. Visualize them within the boundaries of the rectangles.(See Figure 1-1b.)

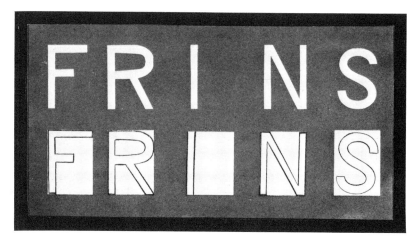

FIGURE 1-1b

The S is the most difficult and may require practice.

Space the finished letters evenly along the band of white backing paper, then glue them in place.

PRESENTATION Put the sign up in the front of the room where it can be seen by the students. Invite them to complete the sentence by thinking of things that only a true friend would do for another such as: "A friend is someone who loans you his gym shoes." "——————————————— can keep a secret." "————————————————loans you his 10-speed for a week." "————————————————gives you his last pencil."

As each child develops a definition that is satisfying to him, be sure and have him write it down so he doesn't forget it. Explain to the class members that they will be making pictures to illustrate their definitions, and that the pictures will include themselves, the friend, and any simple objects or props necessary to complete the idea.

Preliminary drawings can now be made on scratch paper. Have available the following materials for the finalized picture construction:

*9" x 12" colored paper --- background
*bottlecaps (painted with flesh-colored tempera)----------- heads
*yarn or rope --- hair

*assorted fabric scraps-- clothes

*scrapbox--- accessories

Eyes, nose, and mouth can be drawn on the heads with pencil. A dot of pink or red paint finishes the mouth, and a bit of red chalk applied with a fingertip highlights the cheeks. The heads should be glued on to the paper at the contact points and be left to dry undisturbed while the clothing is being cut out. It is a good idea to have several pairs of sharp "teacher's scissors" (borrowed from your friends) available, because young children sometimes have difficulty cutting fabric with their own little scissors.

As the work progresses, things might get somewhat noisy especially with the fun of the "friends" beginning to recognize each other. You might want to break up the work session into two or more periods.

When all the pictures are finished, pass out white strips of paper on which each child should neatly print his friendship definition. These are to be glued to the individual pictures wherever they look best.

DISPLAY Count out enough sheets of 12" x 18" colored construction paper to use as backing. Slice 3 inches off each one on the paper cutter so that they measure 12" x 15", and then glue the pictures to them. The backing paper should be all of one color so as to unify the display. Back your display banner with that color too, and tape it to a wall at your eye level. Then sort out the horizontal pictures and put them in a row directly

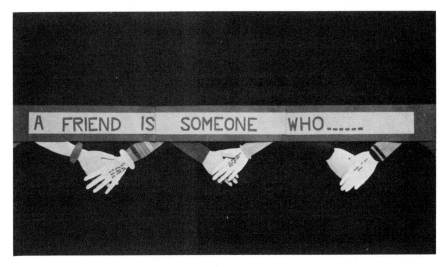

FIGURE 1-1c

under the sign. Begin in the middle, under the word "IS," then alternate from side to side; you'll get an even placement without having to measure anything. The remaining (vertical) pictures will fit in a row across the bottom of the display.

Variation

If you're short on time but would like to obtain the social results of this project, tell the students to draw around their hands and arms on large pieces of flesh-toned paper. After these are cut out, write a friendship definition on top of each and arrange them in a hand-holding pattern under the long display sign.(See Figure 1-1c.)

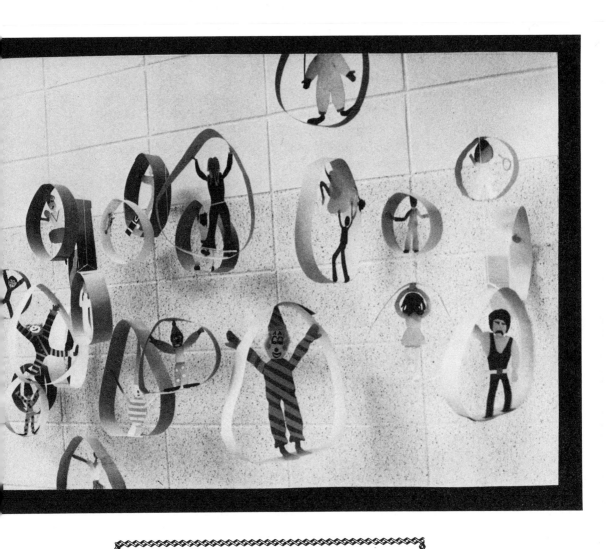

LESSON 2

Moving People Pictures

PREPARATION Choose some pastel-colored 12" x 18" construction paper from your supply room and chop it up into 2" x 18" strips. You will need an average of 2 strips for each student. Then, cut enough 12" x 18" white drawing paper down to 12" x 12" so that each child will have one piece. If compasses for the class are not available, then you will also need to prepare several circle templates of various sizes ranging from 5 inches in diameter to 12 inches in diameter.

It will make your presentation of the lesson easier and provide better motivation if you construct, in advance, an example of the project to show to the class.

Set your compass radius anywhere from 2½ inches to 6 inches and make a circle on the white paper. Inside the circle draw a simple figure of a person posed in such a way as to allow it to touch the perimeter of the circle in at least three places (See Figure 1-2a):

Using one or more of the strips of paper, fit them carefully around the circumference of the circle so that they match it exactly.(See Figure 1-2b.)

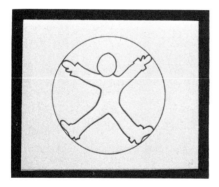 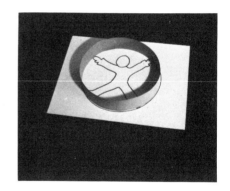

FIGURE 1-2a FIGURE 1-2b

Fasten the strips together and then set this three dimensional circle aside to dry. Meanwhile, cut out the drawing of the person. Clothes should be fashioned to fit the figure's front and back (since both sides will be seen). These can be cut from scrapbox paper and then yarn, string, and fabric used for hair and costume decoration. Facial features can be drawn with crayons, colored pencils or painted with small brushes. Explore all possibilities so that you will know which would be best for your students and your classroom.

Now you are ready for the somewhat delicate job of fastening the figure to the inside of the three dimensional circle. Find the contact

points which you planned during the drawing stage. Attach folded paper tabs (same color as circle) at these points. They should be inserted between the front and back layers of paper for concealment (See Figures 1-2c and 1-2d), and then glue the other ends of the tabs to the inside of the circle. You *could* use clear cellophane tape for this operation; it's a lot easier to work with, but the paper tabs look better, are less expensive, and manipulating them provides an opportunity for the development of small motor skills.

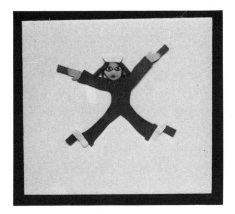

FIGURE 1-2c

FIGURE 1-2d

PRESENTATION Tie a two foot length of string to the top of your circle and put it up at your class's eye level. It should spin freely enough so that the back and front of the figure can be seen.

Pass out the 12" x 12" white paper so that the circles can be drawn, using either compasses or the templates. Talk about the figure that is to go inside. It should bend if necessary in order to touch the edge of the circle *at least* three times. (The larger the circle, the more contact points should be made.) It could be upside down or sideways. It could be a combination of two figures. A unifying class theme might be used such as circus performers, dancers, or athletic contests. Or each student could work on his own separate idea.

Individual choices can be made from the colored strips of paper, and almost everyone will need two of them. Names should be attached to the three-dimensional circles just as soon as they are

completed, since mix-ups could easily occur and would be quite defeating.

Direct the remainder of the project from your own experience of having developed the example. You may see the need for two sessions rather than trying to condense everything into one.

DISPLAY These projects are most effective when hung in a group from the ceiling. The lengths of strings used will be determined by the distance from the ceiling to a point which is a foot below a child's eyelevel. The strings should not all be the same length, since the projects will need to be hung at varying heights. Tie a straight pin securely to the end of each string, borrow a ladder, and instruct some helpers to hand you *one project at a time* to avoid tangling the strings. (It is a terrible mess if this occurs and useful to remember when taking the projects down, too!) Push the pins into the holes of the acoustical tiles so that they are as perpendicular as possible. As each is pinned in place, you must make sure that the circles can swing freely without bumping into each other. It might be necessary to shorten some of the strings to achieve this; your helpers can "spot" for you. Teamwork develops as you move along.

Variations

I

Show construction paper figures from the back only; then cut their large *shadows* from black paper in corresponding action poses. Match each figure to its shadow along the wall. A triangular paper tab will hold the figure out about an inch so that it appears to be casting the shadow.(See Figure 1-2e.)

II

The figures can be glued upright on small cardboard platforms. To these are added whatever a student decides defines *him* and his "personal space". Platforms are suspended from the ceiling with string.(See Figures 1-2f, 1-2g, and 1-2h.)

III

Glue three-inch-square crayon pictures of people in action to 4" x 18" strips of black paper. (Four pictures to one strip.) Fold into cubes and connect with black paper chains. Hang in groups from the ceiling.(See Figure 1-2i.)

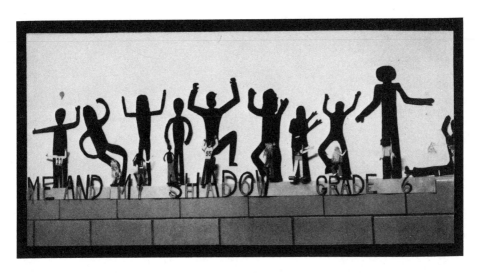

FIGURE 1-2e

FIGURE 1-2f

FIGURE 1-2g

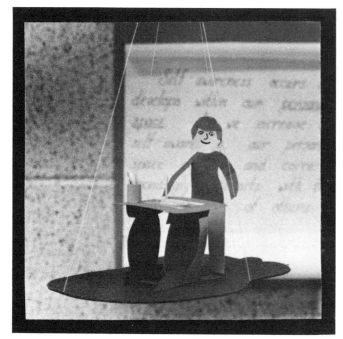

FIGURE 1-2h

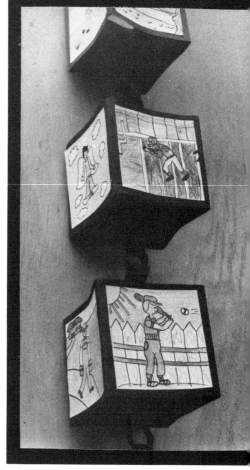

FIGURE 1-2i

If any donations of clear plastic sheets have luckily come your way, you have the ideal medium for this project. Lacking that, unwrinkled clear plastic bags, cellophane sheets, or Saran Wrap could be substituted.

PREPARATION Make an example of the project to show to the class. The idea is to create the illusion of a mirrored image by placing a fabricated paper image behind a light-reflecting transparent surface: a facsimile of a facsimile.

Transform a piece of 9" x 12" black paper into an interesting looking glass shape by folding and cutting any one of a variety of possibilities as in Figure 1-3a.

FIGURE 1-3a

Cut a piece of the transparent plastic material so that it conforms to the shape of the black.

Take on the role of an unusual person looking into a mirror and imagine the reflection. Record this roughly on sketch paper, then

develop the image with pieces of colored construction paper. Use the sketch as a guide and progress in the work by gluing the parts sequentially to the black paper mirror-shape. The shiny transparent plastic can be fastened (with clear tape or rubber cement) on top of the simulated reflection when it is complete. Since this represents an image staring back from the mirror, you need only construct the back of the actual figure standing in front of the mirror. The back must correspond to the "reflection" in shape, color, and texture. It should be reinforced with a strip of cardboard if necessary so that it can be taped at a 60 degree angle on the right-hand side. This position allows the back of the figure and the reflection to be viewed simultaneously.

PRESENTATION Display your example for the class and begin a general discussion about the curiosity each person has concerning his or her appearance ... how we are very interested in seeing ourselves as others see us and how this becomes possible only by using photographic media or mirrors. Explore the fact that people practice all kinds of attitudes in front of mirrors, some of which might be very amusing if captured in a picture.

After preliminary sketches have been made and the mechanics of the construction have been explained, the class can work at its own pace. The lesson had probably best be broken up into three sessions patterned after the knowledge you acquired while creating your example.

The students may require individual assistance with the process of taping the back of the figure to the front of the mirror. Two or three small circles of masking tape will be needed for each and should be positioned so that they are concealed by the figure itself. Experimentation will be necessary since no two projects are exactly alike.

DISPLAY Tape the pictures to the wall in a random placement. Put up a sign with the display to explain to viewers that these pictures are not the "open-up" kind even though they do appear to be of that variety.

Variations

I

Change the subject from people to silver and white frost elves. Display them in an ice palace made of paper and *real* mirrors. Not only can the elves see themselves, the observers find that their own reflections become part of the picture. (See Figure 1-3b.)

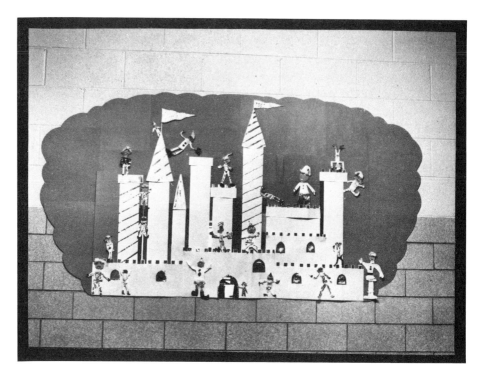

FIGURE 1-3b

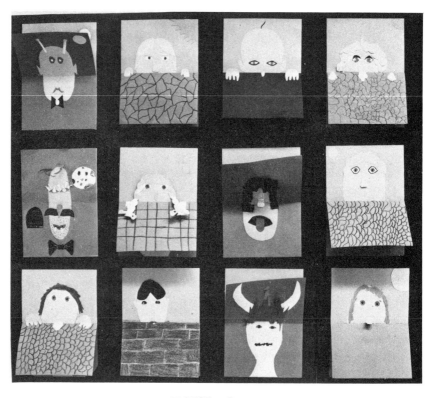

FIGURE 1-3c

28

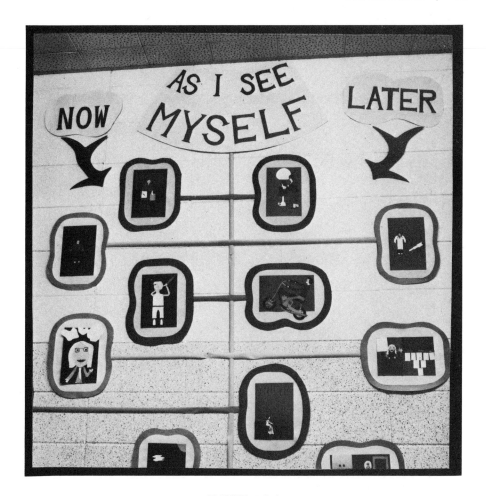

FIGURE 1-3d

II

Omit the mirror idea entirely and emphasize the double identity factor. Two pieces of 9" x 12" paper folded, then glued with their halves back to back provide the basis for lift-up pictures which reveal personality opposites. (See Figure 1-3c.)

III

Positive personality changes can be visualized by the student in depicting his current self-image plus that of the future, as in Figure 1-3d.

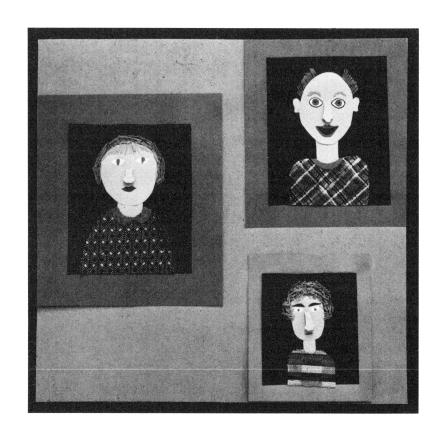

LESSON 4

Spaghetti Heads

Real spaghetti (uncooked of course) is piled above paper faces to represent hair, and the resulting character portraits are indeed very individualized "heads."

PREPARATION You will need about 8 ounces of thin spaghetti for an average class of thirty students. If the material has been donated, you're all set. If not, put it on your grocery list and it will cost you about 25¢.

Pick up a package of 9" x 12" black paper from the supply room and check on the availability of flesh-tone paper—peach, pink, brown, black, green (Martians), yellow, and light blue (Venutians). Your fabric scrapbox will be needed too.

PRESENTATION Pass out the black paper on which the head is to be constructed. Let each child choose from the flesh-tone colors and from this fashion a head shape of any size he likes. Explain that the spaghetti will be used as hair, so sufficient space will have to be allowed around the head so that it may be glued in place. Ears and neck should be added in proportion to the face and a nose fashioned with a folding tab at the top so that glue can be applied only to the underside of the tab, thus allowing the nose to protrude a bit.

Begin the eyes by cutting the irises first (scrapbox paper) and gluing them to appropriately shaped whites.

At this point some personality will begin to show on the face and the students can experiment with clothing styles (shoulders only, or full figure) which would complement the emerging characters.

Pass out the spaghetti (ten sticks to each student) and encourage experimentation with "hair" placement. Some students may want to be very conservative and others may tend to exaggerate. The results should be diverse and above all fun to look at. When final decisions are made, the spaghetti pieces should be fastened in place with plenty of glue. Eyebrows can be added with either more spaghetti or bits of construction paper and then the pictures should be left to dry flat and undisturbed for at least 8 hours.

DISPLAY Trim away any excess black background from around the portraits. Use the paper cutter to do this so that all edges are neat. Matt the pictures on bright construction paper (orange and red are a good choice) and tape them to the wall in a random arrangement. Some of them will be rather weighty and may require additional tape. Better yet, pin them to a bulletin board if you plan to display them for a greater length of time.

Variations

I

Make the faces entirely of spaghetti.(See Figure 1-4a.)

II

Or make designs and pictures on dark paper.(See Figure 1-4b.)

III

Water fountains are an especially challenging subject.(See Figure 1-4c.)

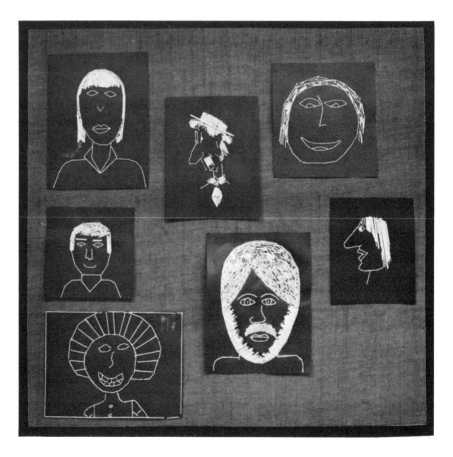

FIGURE 1-4a

FIGURE 1-4b

FIGURE 1-4c

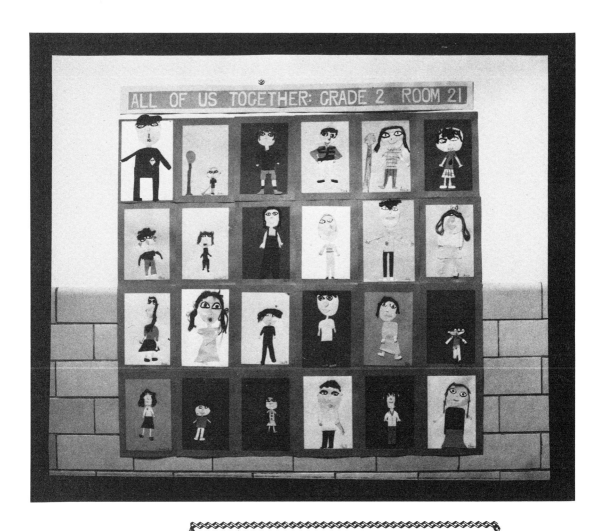

The photograph shows a bulletin board display titled "ALL OF US TOGETHER: GRADE 2 ROOM 21" with rows of children's self-portrait artwork.

LESSON 5

All of Us Together

Whenever you need to strengthen your group's identity, this project will help do that. It also makes a very appropriate display for "Visitors' Day" and is a success with any age group.

PREPARATION Cut flesh-toned paper down to 4½" x 6" size so that you will have enough pieces for all. Also prepare 3 inch squares of white, black and assorted eye colors: brown, green, and blue. Yarn, if you have any, makes great hair; otherwise cut up some paper in appropriate hair colors.

PRESENTATION Since each child will be making a replica of himself, start with the eyes and face as they are the most uniquely definitive part of a person. Pass out the papers mentioned above and with that let each child choose a 9" x 12" colored piece on which to assemble his figure. The children (no matter what their ages) should work along with you at this stage as you demonstrate. Fold the eye-color paper in half and cut both irises at once. Fold the white paper in half and glue one of the irises in the middle. Keeping the white paper folded, cut the (football) shape of the white around the iris to assure proper fit, then glue the remaining iris to the resulting duplicate white. Both eyes should then be glued to the black paper and cut out again leaving a narrow edging of the black all around.

The head shape may be drawn before it is cut. Placing the finished eyes on the face will help to keep proportions relative. Ears can be left on the head (starting just above the level of the eyes) or they can be cut out separately and glued on later. Fashion a nose and a neck from the flesh-tone scraps, and glue in place. The mouth may be drawn directly on the face, or cut from pink paper and glued on. (The latter method is safer!) Each child can now decide how tall his picture person is going to be and glue the head down on the 9" x 12" colored paper at the appropriate spot. Hair can be more easily added then, especially if it's yarn. If hair is being made from paper, it will look more interesting if some texture is added with crayon.

Clothing can be fashioned with scrapbox paper, and it too will benefit from crayon texturing. Cut arms, hands, and legs from the remaining scraps of flesh-tone paper, assemble, and glue to the 9" x 12" colored sheet.

DISPLAY Choose construction paper of a bright color and matt all the pictures on it. Then compute the number of vertical and horizontal rows you will need in order to unify the pictures in one huge square. If you end up with an odd number, use the extra space for the title and room

number. Otherwise make a display banner (as explained in lesson 1) to go across the top.

Variations

I

If you want to occupy less space and are working with older children (they make their heads much smaller), you can group the display to simulate a class photograph—even duplicating the actual photo if you have one. To do this, glue two pieces of 12" x 18" black paper together and make your arrangement carefully so that no fine details on the background figures are obscured by those placed in the front. Attach the figures with circles of masking tape rather than glue, so that the pieces may be returned to their owners when the composite is dismantled. Display the simulated class picture side by side with the actual one for a real attention-getter. (See Figure 1-5a.)

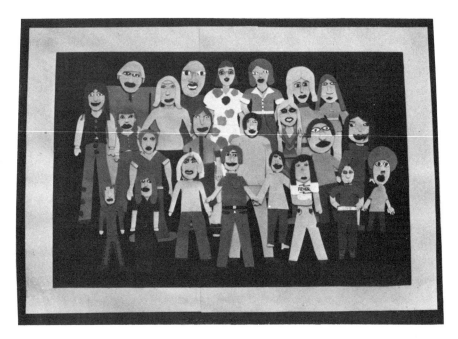

FIGURE 1-5a

II

Use the child's own photograph (school pictures, so they're all the same size) as the head for the figure, and follow either of the already discussed display formats.

III

Limit the project to the faces only and mount each on a balloon shape. Finish off with a balloon seller who holds all the strings. (See Figure 1-5b.)

IV

Show only the backs of the figures and let them be engaged in a common project such as painting a group mural. (See Figure 1-5c.)

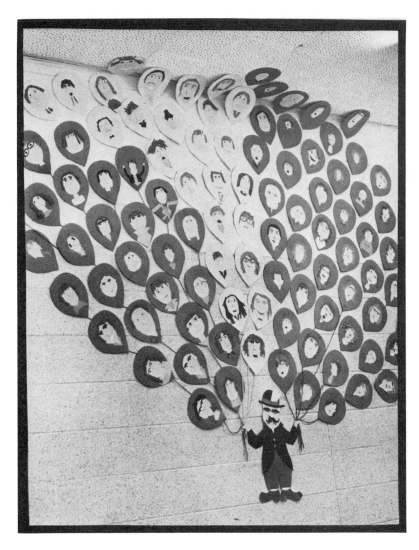

FIGURE 1-5b

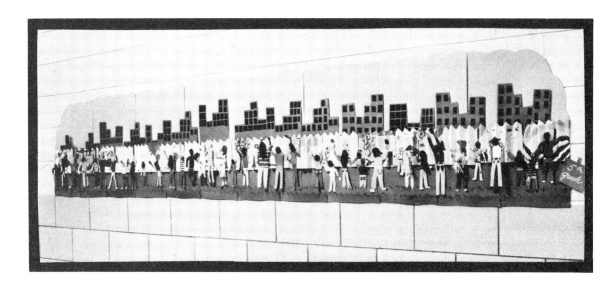

FIGURE 1-5c

CHAPTER 2

ENVIRONMENTAL

MURALS

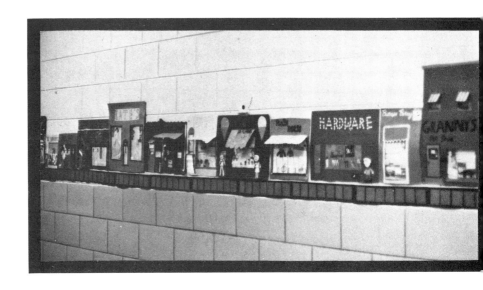

LESSON 1

Main Street

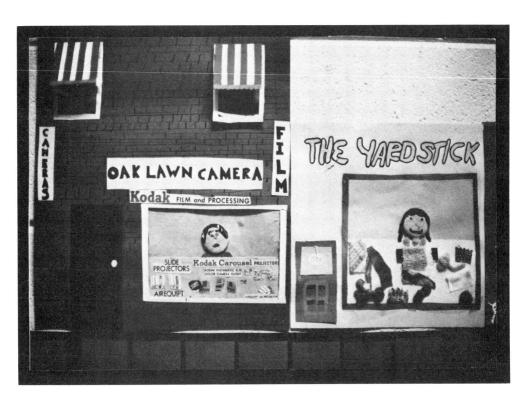

PREPARATION Take a few color snapshots or slides of the stores and buildings on the major shopping street in your school's community. Sometimes picture postcards are available which would be great if you can find them; however, if you have to spend too much time tracking them down, use your camera. You will need the pictures to remind your class of the many different kinds of shops, stores, and services available on just one street of their town.

PRESENTATION Start talking about the many different kinds of stores on "Main Street" (or whatever). Name several of them and ask students to help you remember some more. Write the list on the board as the discussion progresses, and when it is long enough to afford many choices, tell each student to select one store or building to draw. Pass out the drawing paper and while the class is "thinking," demonstrate some techniques they might find useful such as:

White crayon lines (with a ruler) on red paper to simulate bricks. (See Figure 2-1a.)

Black crayon lines on grey paper drawn at random for stones. (See Figure 2-1b.)

FIGURE 2-1a

FIGURE 2-1b

Straight parallel lines for siding or weather boards. (See Figure 2-1c.)

FIGURE 2-1c

Crossed parallels: cinder blocks. (See Figure 2-1d.)

FIGURE 2-1d

Dark brown crayon on light brown paper: wood. (See Figure 2-1e.)

FIGURE 2-1e

Pass around the photographs to provide more help. Then when the drawings are finished they should be filled in with crayon so that construction paper color needs can be explicitly planned.

Each building begins with one piece of construction paper of appropriate size. Any shaping of the paper can be done simply by cutting around the edge; however, very little will be needed since most buildings are rectangular. After the outline form has been established, the entire surface should be textured according to the type of material used in its construction. Refer students to the examples from your earlier demonstration. If roofs show, they should be measured and fashioned to fit the building from paper of a different color; shingles drawn with crayon add more texture.

Doors and windows can be glued in place next, and items to be displayed should be fashioned and arranged attractively with feature or price signs in the windows. Some of these could be cut out of catalogs and magazines—e.g., camera film, soap boxes, toothpaste, or similar printed material.

Awnings look great and add not only color but more dimension. They can be assembled from alternating strips of construction paper or one long scalloped piece which has been striped with paint or crayon. The method for fastening described later in this chapter for the "Pet Shop" awning. (See lesson 7 this chapter.)

Each shop should include at least one clerk and one customer. The customer can be either inside or outside. The salesperson will have to be inside and positioned so that he or she can be seen through one of the windows. When all is ready, the cellophane "glass" needs to be taped on top of windows and doors. A bordering strip of paper might be glued around the cellophane for a more finished look.

DISPLAY Tape up the stores in a straight line along the wall. The display can be unified by fastening sidewalk sections down along the front. These are made by gluing 3 inch squares of grey paper to 3½" x 18" strips of black as in Figure 2-1f.

FIGURE 2-1f

If you have the pieces pre-cut, it becomes an easy project for students who are early finishers. They could also make five or six street lamps to be fashioned from 1″ x 12″ strips of dark grey paper and topped with yellow globes (paper or foil) the size of a quarter.

A street sign at one end of the display becomes another interesting item, and this could bear the name of your class as well.

Variations

I

Expand the project to include the entire town. The buildings would be houses, and construction should be scaled down to accommodate lawns and streets. (See Figure 2-1g.)

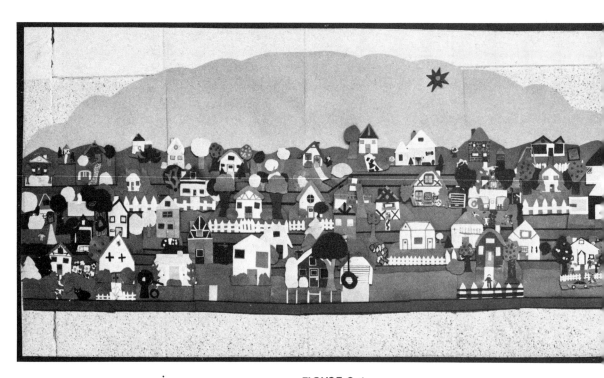

FIGURE 2-1g

II

Make simple houses on a larger scale. Hinge them on the sides so that each will open in the center to reveal the child and his family inside. A good project for Open House. (See Figure 2-1h.)

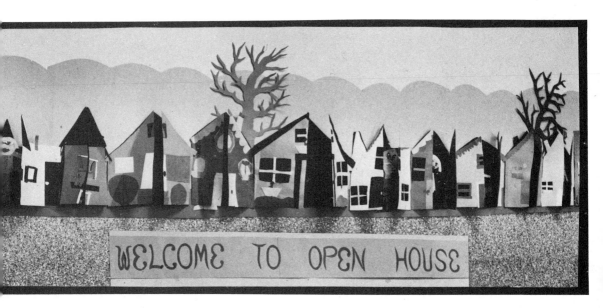

FIGURE 2-1h

III

Place the houses in a row with green 12″ x 18″ lawns and a long continuous sidewalk running in front of the entire scene. Children can depict themselves walking to school in the morning. (See Figure 2-1i.)

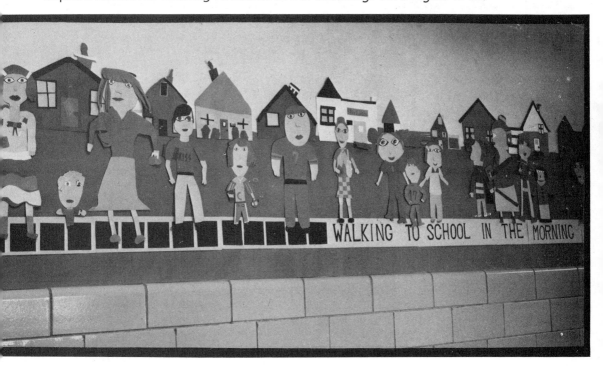

FIGURE 2-1i

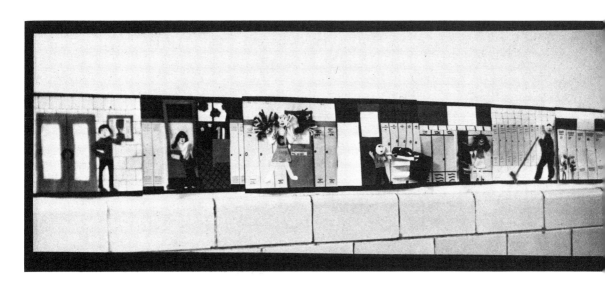

LESSON 2

School Hall Traffic

PREPARATION Because they travel through them every day, students are very much aware of what goes on in the hallways of their school. They also retain a fairly accurate memory of the location of things such as lockers, drinking fountains, classroom doors, offices, washroom doors, closets, bulletin boards, trophy cases, stairways, etc. Tell the class that they will be making pictures of any part of the halls that interests them. The pictures are to include people engaged in some kind of action which might typically take place at that chosen spot. You might take the students on a complete tour of the hallways to refresh their memories or to make new observations. A few rough sketches could be made along the way to serve as resources later.

PRESENTATION Pass out 9" x 12" construction paper to each child. The color should match as closely as possible the dominant floor color of your building. The paper should be used in a horizontal position so that when the pictures are completed they can be put up end to end to create the illusion of one long, continuous hallway. Each student should have his scene clearly in mind before he begins to put anything on paper. Duplicate subject choices should be avoided (if suitable alternatives can be suggested) or collaborated upon.

Backgrounds should be put on first, and if lockers are prevalent, the necessary color of paper should be ready and pre-cut to scale. Need for additional papers will be more diverse, and they can most likely be found in sufficient quantity in your scrapboxes.

If any student wants to make his picture semi-three-dimensional by all means encourage him to do so. Locker doors could be shown slightly ajar. Classroom doors could be functional and/or be fitted with see-through (cellophane) windows. Porcelain drinking fountains could be made of white flint paper or finger painting paper and then fitted with silver foil faucets.

People should be added last—the more varied their sizes and shapes the greater the interest will be. Clothing cut from fabric scraps looks great but is very difficult to cut out. This decision should be based upon the amount of time you plan to allot to the project and the ages of the children involved.

DISPLAY Simply tape up the pictures in a long, continuous line on a wall. You might want to make some special placement of certain classroom doors and hall locations so that a degree of similarity to the school is depicted in the total display. You could also allow it to go around a corner (inside or outside angle) as described in chapter 4, lesson 3; *Cornered River*. Don't worry if things don't match up (on some

pictures, doors may be smaller, etc.); inconsistencies make it all the more fun for people to look at.

Variations

I

Change the subject to classroom interiors. (See Figure 2-2a.)

II

Capitalize on the students' common experience of waiting in line in the hall on Picture-Taking Day. (See Figure 2-2b.)

FIGURE 2-2a

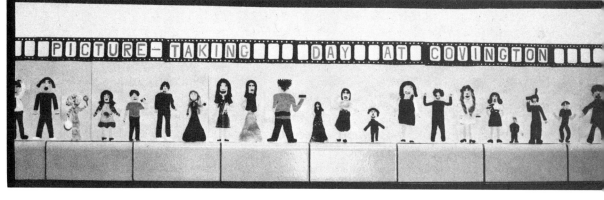

FIGURE 2-2b

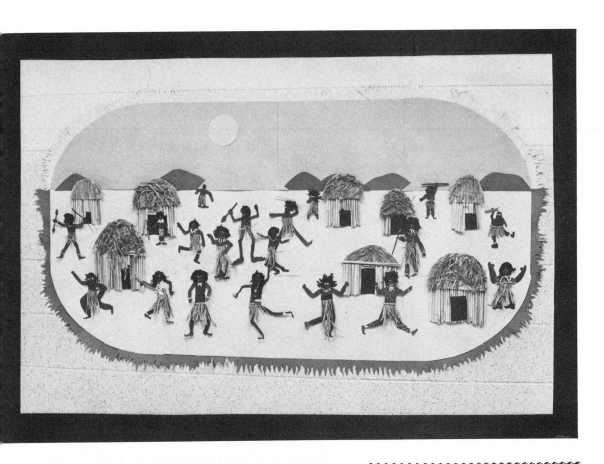

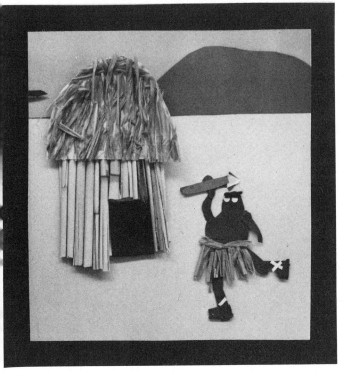

49

PREPARATION You will have to gather most of the materials for this project in the fall and early winter months when plant stems and grasses are turning yellowish-brown. The native huts are made from any material that looks like bamboo such as the dried stems of dune grass, pampas grass, Johnson's grass, or straw. The thatched roofs can be dried grass blades, leaves or, if you want to buy some, raffia. Quantities will of course depend upon the number of children you have in your class, but you can plan on a good-sized fistful of material for each one.

PRESENTATION Since this project connotes hot sunny weather, it might be a welcome one for a cold January afternoon. After talking about life in a warm climate (or tying in with a social studies unit), pass out paper and show the class how to make people (see preparation section, lesson 5 in this chapter). Since these are to be warm climate natives, some suggestions for action poses might be helpful. There might even be several "experts" on the subject among your students.

After the figures have been glued together, they are ready to be clothed and decorated with the dried grass, leaves, and/or raffia. Put these out in wide, shallow boxes and let the students help themselves. Small white pieces of plastic can be made to look like necklaces and bracelets, and tiny colored beads or feathers might fulfill a need somewhere.

Faces need ticket-punched whites of eyes, dark red paper mouths, and a bit of white crayon here and there for marking. Hair (black yarn) should be frizzy and glued about the head in a natural pattern. By this stage the project is almost entirely self-motivating and your students will need very few suggestions.

Making the huts takes almost as much time as constructing the figures, so better attempt it on another day after the natives have been finished. Pass out 9" x 12" yellow construction paper and have the huts drawn in two pieces, a square for the base and a dome for the roof. When they are cut out and temporarily assembled, the size should relate to that of the people. The door opening should be drawn on the square and filled in with black crayon or paper. Surround the doorway with the "bamboo" material you've distributed. Each piece will have to be measured, cut to fit, and glued onto the paper in a vertical position. The dome-shaped roofs are to be covered separately with the dried grass, leaves, or raffia strands. When completed these are overlapped slightly at the top of the house and then secured with glue at the contact points. Leave the houses on a flat surface where they can dry undisturbed for at least 4 hours.

DISPLAY This display can be very simply put up on a rectangular shaped bulletin board, but it is twice as effective if you use a plain wall instead, and shape the background paper into the large oval shape shown in the photograph. It will take a bit more time, but the results will be worth it if you would like something a little more special.

You will need 4 sheets of sky blue paper 18" x 12" size and eight sheets of yellow. Make a stack of two yellow and two blue and cut a constant curve from one corner to another. (See Figure 2-3a.)

FIGURE 2-3a

Tape the two noncurved pieces of blue side by side in the middle of the wall at your eye level. Then attach the two curved pieces at each end as in Figure 2-3b.

FIGURE 2-3b

Working down from that, the next row will be 4 straight yellow pieces, and the bottom row will consist of the remaining yellows (2 straight and 2 curved). (See Figure 2-3c.)

Cut seven or eight low rolling hills from two shades of grey paper. These should measure 3 inches high at the most and will alternate along the top edge of the yellow paper to help soften the horizon line and create the illusion of distance.

The huts are going to be heavy and each will require at least six circles of tape to secure them to the background. Sort them into two or three size categories. The very smallest should go close to the background and should be put up first. Work down toward the bottom of the display to the foreground where the largest huts would be seen. Overlap some, if you have to, in order to achieve an interesting grouping.

The natives too will have to be arranged back to front according to size. They can be grouped or placed directly in front of some of the huts wherever you think best; just make sure that important details are not being concealed.

Border the edges of the display with some free-form points which could be associated with tropical plants or heat radiation. To make them, prepare twelve strips of brown paper 9" x 2", then stack three or four at a time and cut a series of points as in Figure 2-3d.

These sections will go around the lower yellow portion of the display. Cut nine more of them from yellow paper and use around the sky area. When all is complete, put a yellow sun in the sky to glow warmly over all.

FIGURE 2-3c

FIGURE 2-3d

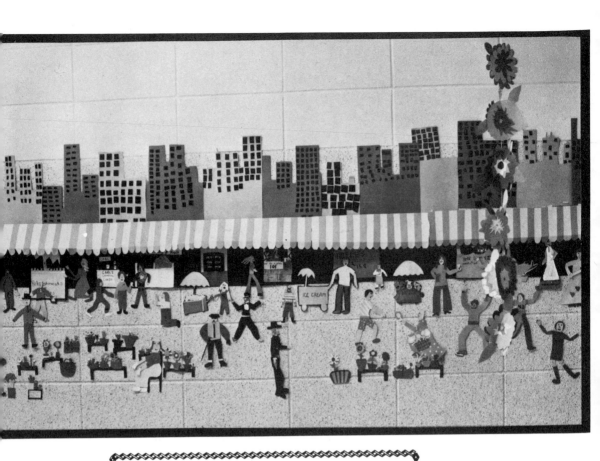

LESSON 4

Flower Market

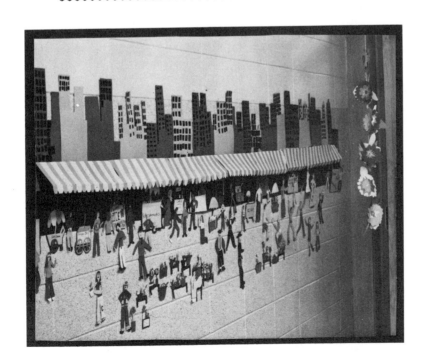

PREPARATION This open-air market looks like summer and lightens winter gloom. So you might want to think about doing it in February, after the fun of Valentines is over. It needs a long, long awning both for the final display and for original motivation, so you might as well begin with that. Awning sections can be worked upon by students during free-time period. Very little instruction will be needed if you provide one example for them to follow and have the materials available in one corner of the room. Cut three sheets of 12" x 18" yellow paper in half lengthwise and make long, one-inch folds inward along both 18" sides (See Figure 2-4a.).

FIGURE 2-4a

If you score the paper first with a ruler and ballpoint pen, the folds will be neater and more uniform. Cut fifty-four strips of orange paper 5" x 1", fold back one inch at the end of each one, then round off that end as in Figure 2-4b.

FIGURE 2-4b

At this point you will only need to round off nine of the strips for the example you are making; the children can round off the remaining ones as they need them.

In a similar manner, make scallops along the edge of the yellow paper at one inch intervals, then snip off the nonscalloped interim places (See Figure 2-4c.).

FIGURE 2-4c

Glue the orange strips to the long yellow paper in an alternating way to produce stripes, as in Figure 2-4d.

FIGURE 2-4d

The five remaining awning sections can be completed by students following your example whenever time permits.

PRESENTATION Tape two or three of the awning sections in a row across the chalkboard. Sketch some city buildings in back of them and some small shops and refreshment stands underneath. (See lead photograph.) Explain that this is to be an "open-air" market where sellers set up a variety of wares in somewhat temporary locations, and many diverse customers are attracted by the low prices. Emphasize the fact

that flowers are the most prevalent and colorful items sold in such a place, and for this reason it is sometimes referred to as a "flower market," even though a wide range of other merchandise is available.

Each student will make three things: a stand (or tables), items to be sold, and a person who is either a seller or a buyer. If you get some "I can't draw people" groans, look at lesson 5 in this chapter and present the figure-drawing part of it. The people should be completed with either cloth or paper clothing plus numerous fine details, and not until they are finished should work on the stands begin.

Some students may want to collaborate with a friend at this stage, and that should be encouraged as long as the work is shared equally between them. Proportions of the stands and merchandise should relate to the size of the people and, in turn, to the size of the awning which will pull the display together. Attention should be paid to small details and accessories such as signs (neatly lettered with small marker or pen), umbrellas (for stands not to be placed under the awning), food containers, flower or plant containers, packages, booth texture or decorations, food-preparation equipment, and condiments. Students will probably contribute good suggestions to each other, so you might allow them to move about the room freely at this stage of the project.

Anyone finishing early can fashion the city buildings which are to be in the background. They can refer to your chalkboard sketch to get some idea of size and then cut rectangular forms from two shades of grey paper. Very small black rectangles will look like windows on the buildings if they are glued in vertical or horizontal rows. This is a good quiet part of the project and is also very easy, so any student who needs to feel a measure of success at this point will attain it. It is also a good way to calm down some of the activity which might have made the class noisy, so if the building-makers are prolific, don't worry—you can use them all.

DISPLAY Tape all six of the awning pieces along the wall where the display is to remain. They should be positioned a little below your eye level and will protrude out about four inches. Directly under the place where the awning sections are fastened to the wall, begin a row consisting of nine pieces of 9" x 12" black paper running lengthwise. Tape the stores and/or booths intermittently on top of the black wherever they look best, but keep the base line constant as you proceed. Scatter the people in front of the stores wherever they belong. You might have to enlist class help for this to avoid mistakes or dissolving partnerships. Independent stands such as pushcarts, benches and tables, or groupings of flower and plant containers can go down further

on the wall in positions consistent with the activities depicted. Again, the people will need to be strategically placed.

Put up the buildings above the awning, but tuck their bases down just a bit so that they are hidden. You want to create the illusion of the buildings being in the distance which precludes any sight of their lower portions. However, take care not to poke them down too far or you might loosen the awning.

If your school happens to be located in a rural area, you might deem it more meaningful for your students if this flower market is placed in a more familiar setting. To do this, simply substitute green hills or mountains for the row of city buildings in the background, and add a large shade tree at the end of the awning. Replace some of the flower stands with bins of vegetables.

Variation

Personified giant flowers make a long, colorful, hallway display. These are three feet high and reach out with green hand-leaves. (See Figure 2-4e.)

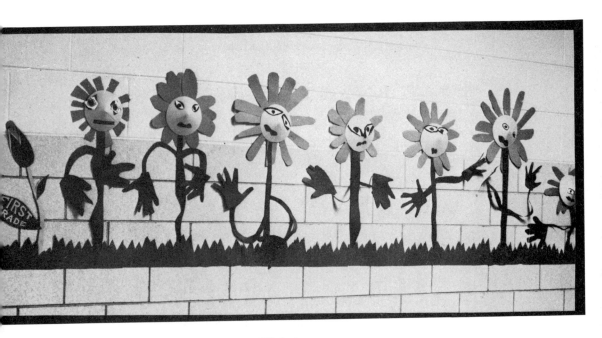

FIGURE 2-4e

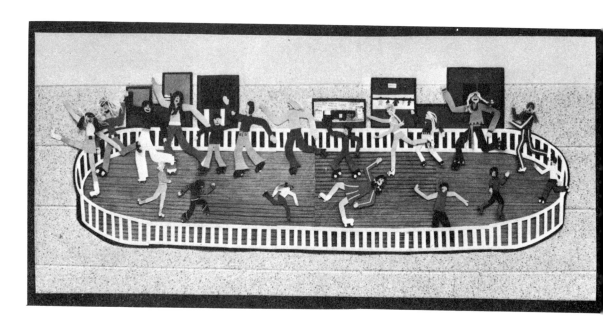

LESSON 5

Roller Rink

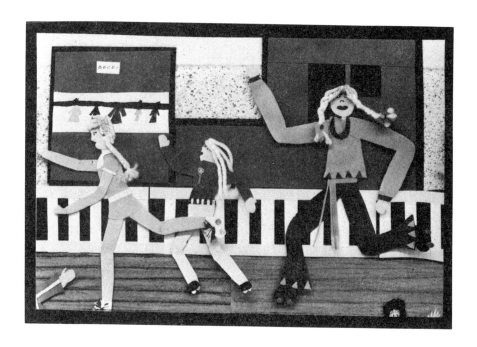

PREPARATION Familiarize yourself with this basic and simple way to construct a figure in action. Once understood, it becomes a very effective antidote to the "I-Can't-Draw-People" syndrome.

Fold a piece of 9" x 12" flesh-colored paper in half lengthwise and draw the following parts (See Figure 2-5a):

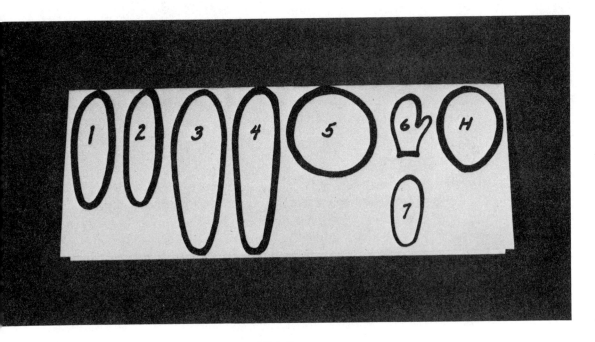

FIGURE 2-5a

Number the parts as shown in the diagram. As they are cut out (two of each because the paper is kept folded), the duplicate parts should also be numbered. Then line up everything in sequence as in Figure 2-5b. To assemble the figure, begin at the two number 5 pieces and overlap them slightly. This makes the torso. Next attach the number 1's at the top of the torso to define the shoulder and upper arms. Continue to assemble the figure until it is complete except for the head and neck. (See Figure 2-5c.)

Experiment with several different positions before the final gluing. Be sure to bend at the joints for action.

The head and neck should be fashioned separately (same height as the number 7 piece), and it will be either an oval-shaped front view or it may be a profile. This would depend upon the type of activity being depicted.

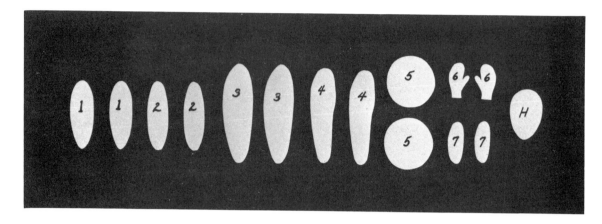

FIGURE 2-5b

PRESENTATION When the basic body shapes have been prepared, they should be arranged in the action positions of roller skating. Children of all ages are quite familiar with this activity, either from participating or watching. Either way they can try out a wide variety of skating poses with the paper figures before gluing them in the final position.

Skating costumes can be fashioned from scrapbox paper since a wide range of colors will be needed. These can be accented with tempera paints or watercolors plus India ink or marker.

Roller skate wheels are punched out of colored paper with a ticket punch and then glued to the shoes. Be sure wheels are aligned to make contact with the floor.

Facial expressions should be drawn with pencil first and then outlined in pen or fine-tip marker. Paint applied to the features is most easily done with a very tiny paint brush, and if you don't have a lot of these, the painting operation will have to be alternated with another phase of the project.

Colored yarn or clippings from carpet scraps make interesting hair when glued in strands or clumps to the head. The style should be appropriate to both the person and the activity.

As the figures are finished, the students may begin to collaborate on creating refreshment stands, first aid stations, or other booths which are found at a roller rink. These may range from simple to complex creations, but all should be of the same scale. Other "extras" to be made for the project will be floor boards and guard rails. For the floor, cut four pieces of 12" x 18" light brown paper in half lengthwise. Then distribute one to each of eight students who are not busy with something else. Tell them to select four crayons in the yellow, brown,

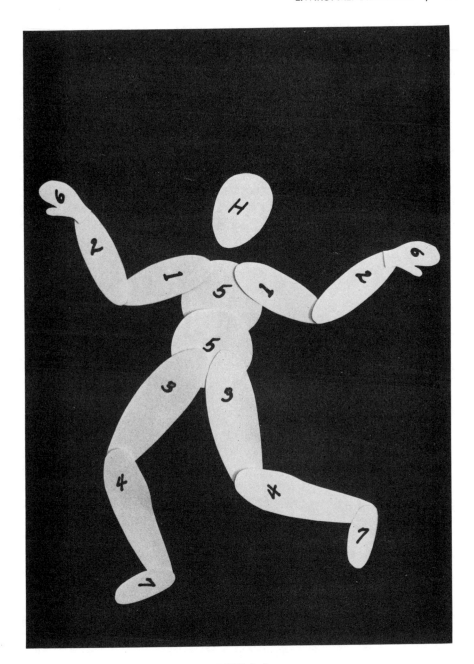

FIGURE 2-5c

and orange color range and draw evenly-spaced lines (one-half inch apart) lengthwise on the paper. (Eighteen inch rulers are ideal if you have some. If not use eighteen inch pieces of paper as straight-edges.)

The other colors are to be applied very heavily between the lines in streaks so that the finished effect is one of very shiny floorboards. The guard rails are a little more complicated. You will need to have pre-cut (on the paper cutter) about 120 white strips of paper one-half inch wide and three inches long. (This isn't as horrendous as it sounds because in a series of stacked cuttings you get seventy-two strips from one 9" x 12" piece of paper.) You will also need twelve strips ½" x 18". The small strips are attached to the long ones, ladder fashion, and this produces six straight guardrail sections which can easily be completed by students. It might be best for you to make the curved sections yourself. Fold a piece of 9" x 12" white paper in half crosswise. Placing the fold at the top, draw a continuously curving line from one corner to another as shown in Figure 2-5d. Draw this line with a one-half inch wide piece of crayon used flat. That way your curve will be half an inch wide at all points.

FIGURE 2-5d

Keep the paper folded and cut out the railing. When it is unfolded, you will have one continuous curve. Trace around it, on new paper, three more times so that you have four identical curved pieces. Lay these flat, allowing three inch spaces at the ends, then fill in the vertical strips. (See Figure 2-5e.)

DISPLAY Put up the floor sections at a child's eyelevel in a double row. Arrange the booths and stands along the top edge beginning in the

middle and expanding toward the sides. Along the same line, place three of the straight railing sections. Some of the floor sections will be left extending out on each side, and on top of these, place the curved railing pieces as in Figure 2-5f.

FIGURE 2-5e

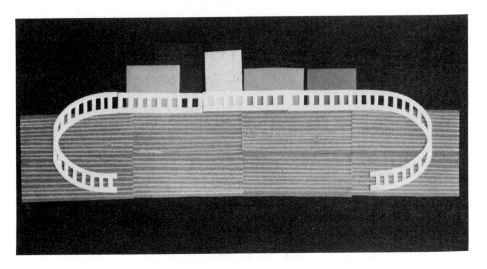

FIGURE 2-5f

Excess flooring will have to be trimmed off around the curved end-pieces in order to conform to the oval shape. (Use a razor blade if you have one handy; otherwise scissors will do the job, though more slowly.) The remaining straight rail sections will fill in the bottom between the curves, and should fit exactly.

Sort out the skaters in terms of the direction they are facing. The ones heading toward the left go along the back part of the floor, while

the ones for the front will be facing right. This placement creates the illusion of skaters traveling in a counter-clockwise direction, and you'd better get that right or you'll be corrected immediately by the first students who view the display.

Variations

I

Switch the setting to an indoor ice-skating rink by substituting grey paper for the wood-toned floor. Or move the entire scene outdoors to a frozen pond.

II

Keep the setting the same, but change the activity from roller skating to disco dancing. (See Figure 2-5g.)

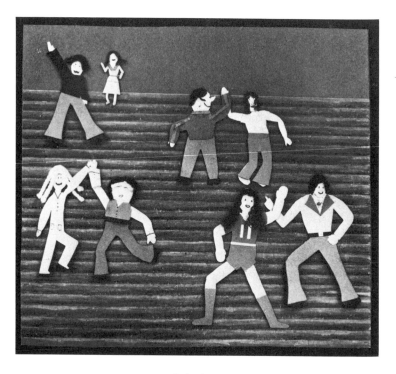

FIGURE 2-5g

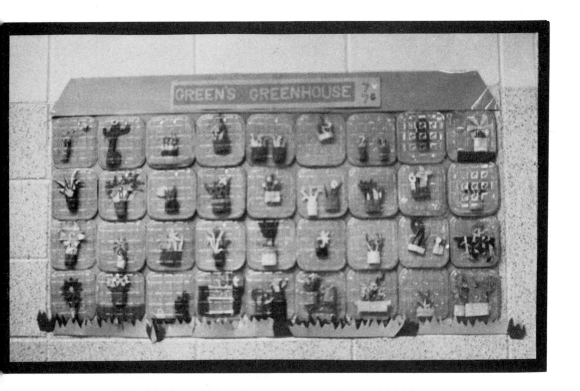

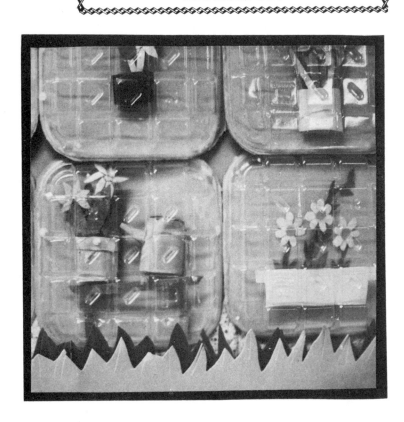

PREPARATION Ask the meat manager at your supermarket if you can buy some of those clear plastic trays used for packaging hamburger. You'll need one for each student, and chances are good that he'll donate them to your class. The trays are going to represent glass walls and each one will frame a miniature (paper) plant. When assembled and displayed, the overall effect is that of a large greenhouse.

The class will be more easily motivated if you make up a small example to show at the beginning of the lesson. That's not essential, but doing so would make you more able to anticipate difficulties if you have directly experienced the project yourself.

PRESENTATION After explaining the project (and showing your example if you have made one), pass out the plastic trays and a 6" x 6" piece of light blue paper. The children should trace around the trays and then cut out the shape so that the blue paper will fit over the opening exactly. All the work will be done on the blue paper and the trays will not be needed again until the very end of the project.

Demonstrate how to make a paper flowerpot from a cylinder. Use a large piece of paper so everyone can see what you're doing, but explain that they will be making miniature pots from smaller pieces of paper. Let students choose from a variety of colors (either pre-cut 6" x 4½" rectangles or scrapbox paper) and begin to experiment with the container construction. Some of them will expand on the idea of a simpler cylinder and come up with sprinkling cans, hanging baskets, square planter boxes, etc. (Care should be taken so that the pot doesn't stick out so far that it will not fit inside the plastic tray.) When the flower pots are finished, they can be glued to the blue paper in an appropriate spot and the focus of work can be shifted to making the plants to fill them.

Find as many shades of green paper as you can and distribute small quantities of each. A variety of leaf and stem shapes could be drawn on the board to get things going. (See Figure 2-6a.)
These are then glued all the way around the inside rim of the small flower pots to achieve some depth, as in Figure 2-6b.
A variety of bright colors plus white should be available for flower making. Again, paper from the scrapbox can be used successfully. The flowers should be made in proportion to leaves, pot, and the remaining unused space. Some suggested flower forms might help here too. (See Figure 2-6c.)

When the entire composition is complete and glued to the blue paper square, the plastic trays must be fastened on top of that square

FIGURE 2-6a

FIGURE 2-6b

FIGURE 2-6c

with clear tape. It's the only thing that works. Two pieces for each of the four sides will be enough. (See Figure 2-6d.)

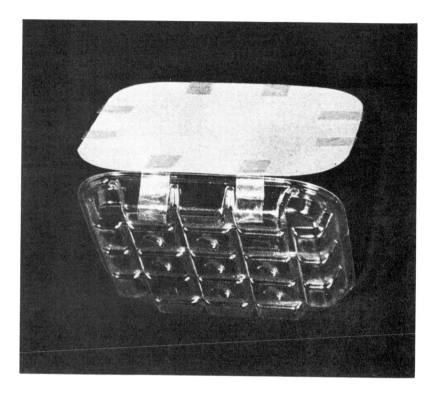

FIGURE 2-6d

DISPLAY Count the finished projects and factor the number so that you can determine how many rows to make and how many "windows" will have to be placed in each row. All together they should form a long low rectangle to suggest a greenhouse. Attach four circles of masking tape to the back of each unit, and then press them onto the wall in the determined order. Measure the top of the completed rectangle and cut an angled roof to fit across it. The roof should be made from light blue paper and, if possible, covered with cellophane or clear plastic to continue the glass effect. Discuss with the class an appropriate name for the greenhouse and then make a cut paper sign for the roof. (See how to cut letters in Chapter 1, lesson 1.)

Tape a row of grass along the bottom of the building. Cut it free-form from several 1" x 9" strips of green paper.

This will hide the bottom edges of the trays and give a more finished look to the display.

Variation

Mount the flower-filled trays as before, but display them as if they were bay windows or sunroom windows in apartment buildings. Cover large sheets of paper with the building textures shown in the "Main Street" project. Then tape the windows to the paper and add some doors. (See Figures 2-6e and 2-6f.)

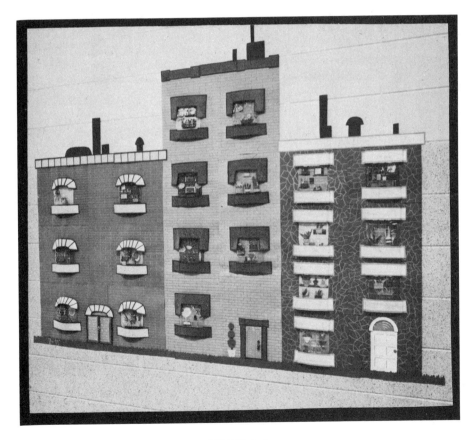

FIGURE 2-6e

FIGURE 2-6f

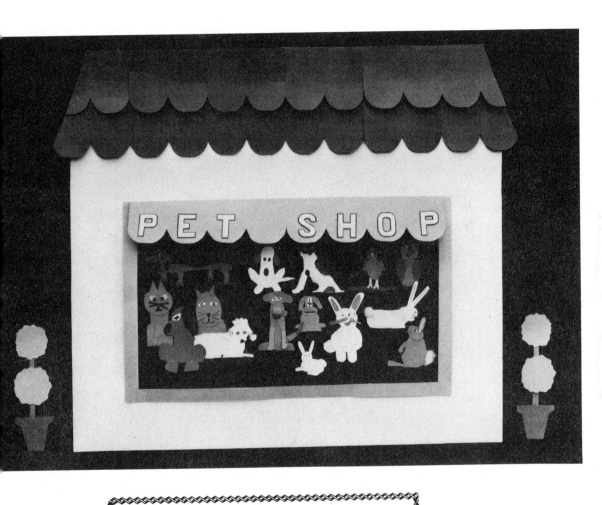

LESSON 7

Pet Shop

PREPARATION Find some empty wall space (either in your classroom or school hallways) that measures at least eight feet wide and six feet high. Or, if a gigantic bulletin board exists with those measurements, use that. At the center of your chosen space, tape (or pin) twelve sheets of 9" x 12" black construction paper so that together they form a large rectangle. (See Figure 2-7a.)

FIGURE 2-7a

This is to be the window part of a pet shop which will then need to be surrounded by sixteen more sheets of construction paper (any bright color) to form the store.

Choose a different color of 9" x 12" paper for the roof and count out twelve sheets. Scallop them into shingle sections by cutting through four at a time. (See Figure 2-7b.)

At this point you might also scallop four additional sheets of a different color to be set aside and later used as an awning.

Fasten the roof along the top of the store in such a way that the scallops barely conceal the upper edges of the paper. The roof will be six inches wider than the building, so allow three inches extension on each side. The top row of shingles should overlap the first. Bend each row out a little at the bottom for more dimension, then shear them off at an angle at each end. (See Figure 2-7c.)

Bend back the four awning pieces two inches from the top of each and fold sharply, as in Figure 2-7d.

FIGURE 2-7b

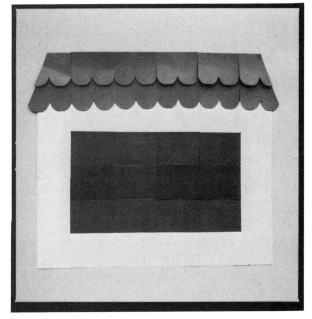

FIGURE 2-7c

FIGURE 2-7d

Attach these in a row across the top of the black window. Cut out block letters for the words "PET SHOP" (see Chapter I, lesson 1 for letter-cutting instructions) and glue them across the awning.

PRESENTATION Show the empty pet shop to your class and discuss the kinds of pets which might be seen in the window. Dogs seem to be a favorite subject (although the gerbils, cats, and more esoteric pets such as snakes and parrots need not be neglected). Make available a variety of 9" x 12" construction paper in white, black, orange, yellow, and as many different shades of brown as you can manage to find. Plan for each child to need at least two pieces of paper. Since the animals will be sitting down, the legs and shoulders should be cut out first. (See Figure 2-7e.)

FIGURE 2-7e

These should then be matched up to thigh sections which should be drawn as they would appear in back of the front legs. (See Figure 2-7f.)

FIGURE 2-7f

The face can be done in one or two parts and as many colors. Each student should practice drawing the face of his pet on a piece of scratch paper. When shapes and colors have been decided upon, they will be ready for final construction. (See Figure 2-7g.)

FIGURE 2-7g

Eyes and nose may be fashioned from scrapbox collections. Furry textures can be created by carefully planned crayon application. No scribbles—every line should mean something.

Students who finish early might be interested in working in a group to construct two identical topiary trees to add further appeal to the display. Parts can be cut in duplicate and then assembled individually: pots, twelve inch green circles, and nine inch green circles. (See Figure 2-7h.)

FIGURE 2-7h

After these shapes are asembled, with stems in-between, they may be decorated with simple flower forms. Or, if time has run out, leave them unadorned.

DISPLAY The pets should be arranged in two rows in the black window area. Start the back row in the middle then overlap the next row in front being careful not to hide the major features of the animals. When the composition is complete you can call it finished, but if you happen to have enough cellophane to reach across, place it right over the animals and secure it with tape at the sides to simulate window glass. A two inch border of white paper should be fastened all around the window to conceal the cellophane tape. Don't forget to put up the topiary trees. Set them a little lower than the building to add more depth.

Variations

I

Omit the shop and make all pets on a smaller scale. Perch each one on top of a table to create a PET SHOW. (See Figure 2-7i.)

II

Limit the pets to monkeys only, and see how much fun they have coming out of barrels. This display will generate even more enthusiasim if it is arranged high up on the wall, close to the ceiling. (See Figure 2-7j.)

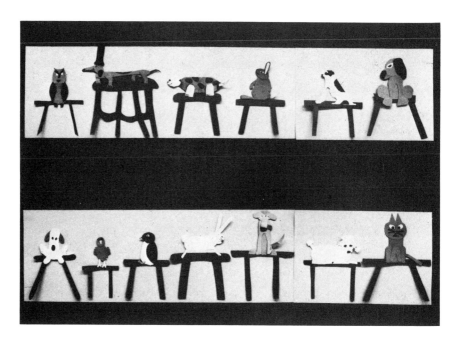

FIGURE 2-7i

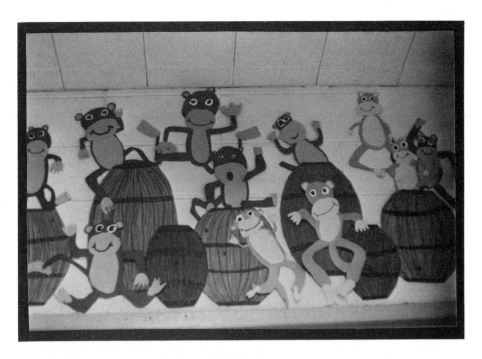

FIGURE 2-7j

FIGURE 2-7k

III

Limit the pets to cats only—tiny furry white ones no more than three inches high. Display them in pods on a giant branch for some very unusual PUSSY WILLOWS in early spring. (See Figures 2-7k and 2-7l.)

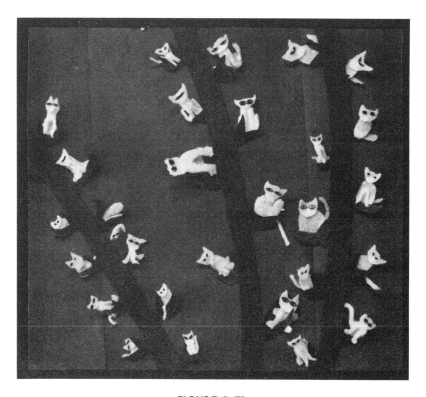

FIGURE 2-7l

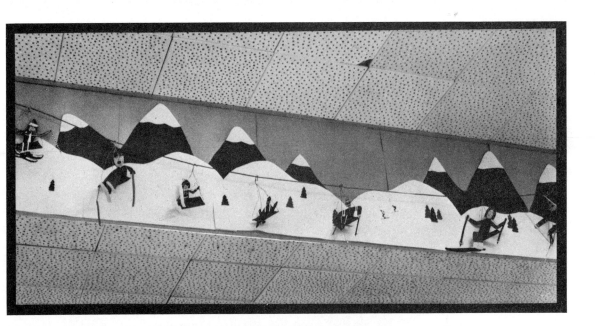

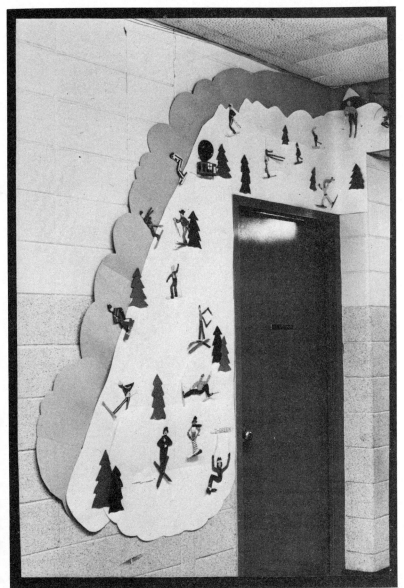

PREPARATION This display will attract a lot of attention no matter where you put it, but it will really get spectators involved if you string the ski lift across a hall ceiling and then show the skiers sliding down an adjacent wall. Before you present the idea to your class, construct the "chairs" for the ski lift. (You'll have to do this eventually anyway, and advance preparation will aid in student motivation). Start with a three inch square piece of construction paper and make two folds at one inch intervals. (See Figure 2-8a.)

FIGURE 2-8a

Cut two 12 inch lengths of very thin wire and lay them along the folds so that equal amounts protrude on each side, as in Figure 2-8b.

FIGURE 2-8b

Now crease the paper inward and glue each section down securely. Keep the wires inside the folds as you do this. (See Figure 2-8c.)

FIGURE 2-8c

Bend all four wire ends up so that they meet directly above the base and form the apex of the structure. Twist them together securely at this jointure and fashion a small hook at the top. (See Figure 2-8d.)

FIGURE 2-8d

Make enough of these "chairs" to go across your hall ceiling at one-foot intervals. Eight of them should be about right.

PRESENTATION Tape a wire along your chalkboard close to the top and hook several of the "chairs" to it. Then draw a long descending

chalk line from the wire to the chalk tray. Ask the students to imagine that here is a ski lift next to a snow-covered slope. Skiers of all descriptions will be needed to fill it up, and each member of the class will be making one of them. Before any work is begun on the people, a few preliminary plans should be discussed.

If a student decides to make his skier sitting on one of the chairs, both the front and back will show and will need to be clothed. Also, these figures will have to be semi-three-dimensional, since they will be bent to fit the chair and their skis will be attached perpendicular to their feet.

Skiers who are to be placed on the slope should be assembled in such a way that they will all appear to be going down the hill in the same direction. (Refer them to the chalk line example previously discussed.)

Other forms of action can be depicted too, such as the fallen skier who is stuck in the snow, the frightened beginner, the show-off, the rescue squad, the expert, and the average performer. Each will be unique.

When plans are fairly well made, present the figure construction method from lesson 5. Or, if you think your students can feel the action of the pose without it, they should proceed on their own. They might gain more help by using each other as models, and every one of them should practice the skier's stance of bent knees, forward weight placement, and pole balance. They need not have actually experienced skiing to achieve this—just imitate. After figures are glued in the final pose, they can be clothed with standard skigear or creatively zany attire. Scarves, hats, goggles, and mittens would be necessary accessories. And of course the skis and poles are essential. Care should be taken to get these in good proportion to the figures. A bit of tempera paint plus a supply of very small brushes would be useful for costume decoration. Facial expressions can be done in ink, paint, marker, or a combination of all of these and should attempt to reflect whatever emotion is being experienced by the individual.

DISPLAY String a thick wire rather loosely across the hall ceiling. It can be attached at each end with masking tape or, if you have acoustical tiles, pinned perpendicular to the holes with straight pins. If the hall ceilings in your school are exceptionally high, then position the wire about nine feet from the floor. Sort out the number of skiers which were made to be seated in the chairs; bend them in the appropriate places and slide them into their seats, then hook these over the wire at regular

intervals. Be sure one of them is hanging right next to the wall to give continuity to the end of the ski lift and the top of the hill.

You will need twenty-seven sheets of 12" x 18" white paper for the snow-covered slope. Begin it by taping up a column of six pieces of paper, end to end, so that the top edge touches the feet of the first seated skier. Make another six piece column immediately next to the first and then continue with a five piece column, a four, a three, etc., to produce something that will look like a white staircase. Convert this into a hill by drawing an irregularly curved line from top to bottom, as in Figure 2-8e.

FIGURE 2-8e

Then cut off the excess paper along the line. Blue sky behind the white hill provides color and edges the display nicely. To prepare this, stack seven sheets of 12" x 18" blue paper and cut random convex curves along one edge. After applying tape to the backs, poke them down behind the white paper, as shown in the display photo.

You will be needing seven or eight evergreen trees of various shades and heights. Scatter them around your hill at random, and place some together in overlapped pairs. Beneath the trees, add some rounded-off snow drifts. (You can make these from the scraps cut away earlier when shaping the slope.)

Now the scene is set for the remainder of the skiers. Placing these in appropriate spots and positions is a lot of fun—which you deserve after all this work. They can be skimming down the side of the hill, falling in it, partly hiding behind trees, plowing through a drift, recovering from a fall, socializing, or just plain having fun. If you happen to be a skier yourself, you will undoubtedly be able to bring many more interesting ideas to the situation.

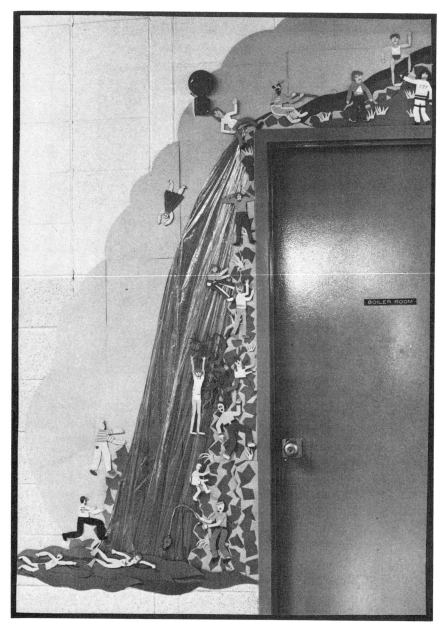

FIGURE 2-8f

Sometimes the architecture in school hallways includes a crosswise fascia arrangement where a higher ceiling meets one that is lower. If that can be found in your school, use it for this display because it will make it even more effective. Back the fascia with a continuation of the sky blue paper you used as the edging above the hill. In front of the sky place a row of purple snow-capped mountains; and then in front of them, and along the lower edge of the fascia, a series of small snow hills. Put in some tiny evergreens and, if one student can manage it, some miniscule skiers painted right on one of the hills. All this will create distance and provide the perfect place and background against which to hang the ski lift.

Variations

I

Substitute blue paper for the large white ski hill, and cover it with a nine-foot length of plastic food wrap. Ripple the material as you tape it to the paper so that it has the look of a floor-to-ceiling waterfall. Edge this with a rocky gorge and some plants and trees; position the people wherever possible. Extend the river up across the fascia and add more people there too. (See Figures 2-8f and 2-8g.)

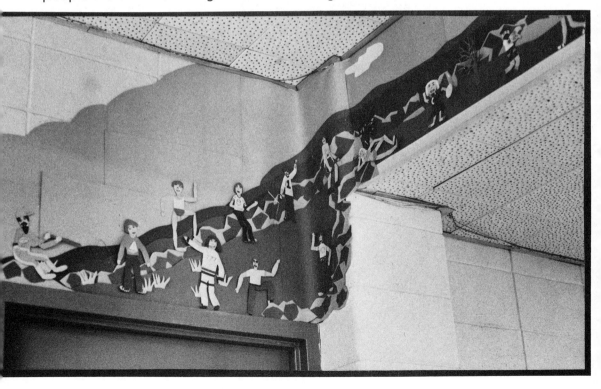

FIGURE 2-8g

II

Use a building as the high background and let it appear to be in the process of construction. The people would be the workers who are on the job. (See Figures 2-8h and 2-8i.)

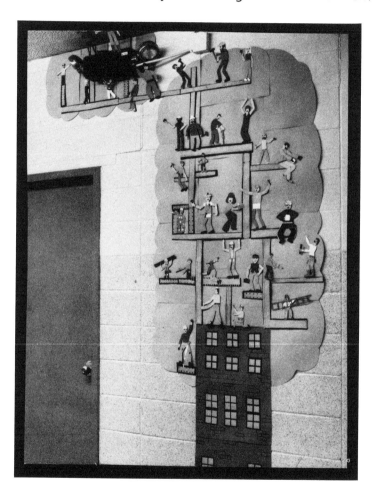

FIGURE 2-8h

FIGURE 2-8i

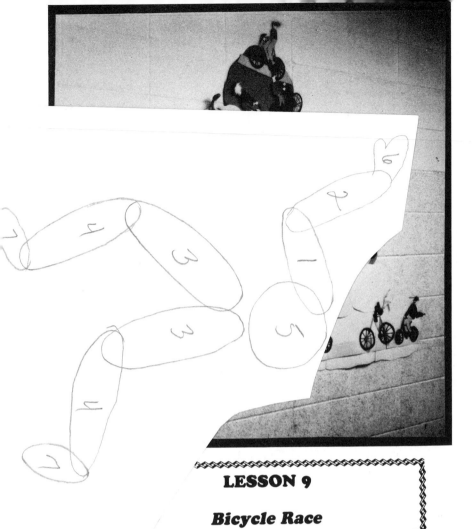

LESSON 9

Bicycle Race

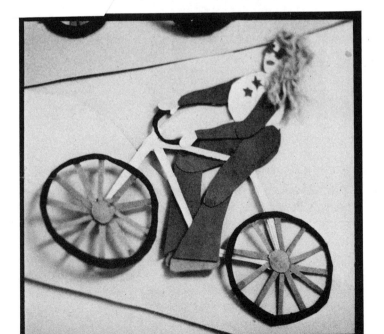

The bicycle is probably the single most important piece of equipment that a child may own or hope to own. For that reason, students will be immediately interested in the challenge of constructing not only the bicycle, but a facsimile of himself riding it in a race or procession.

PREPARATION First make the bicycles, and to do that begin with the wheels. Pass out paper to each child: 6" x 9" black and 6" x 9" grey. You should work in front of the class and make a very large wheel, step by step, to show them how. Compasses will be needed. Great if each child has his own, and if not, they will have to be shared. However, if your students are below fourth grade, it would be a lot easier for them to use prepared templates for the bicycle tires.

PRESENTATION Set the compass radius for 1 ¾ inches and draw two circles on the black paper. Reset the radius for 1½ inches, and taking care to get the compass point exactly where it was, construct another circle inside the first. The tires should then be cut out carefully and set aside. Cut some very narrow strips of grey paper for the spokes. Six will be needed for each wheel, and they can be six inches long (to be trimmed later). Cross two strips at the center of each tire and secure with glue where they touch the black. (See Figure 2-9a.)

FIGURE 2-9a

Distribute four more spokes evenly between the first and fasten in place. When the glue is pretty well set, trim off the parts of the spokes that protrude beyond the black rim, then turn over and fasten a very small grey circle at the center to conceal any inaccuracies.

Set the wheels aside to dry thoroughly and begin on the pedals and chain pull. Cut a circle from the grey paper about the size of a quarter and hollow it out. (Just bend it in half and cut into the fold). Lay

a two-inch strip of grey across it diagonally and then attach two black pedals parallel to each other, as in Figure 2-9b.

FIGURE 2-9b

Lay out an assortment of colored paper 6" x 6" and let each child choose one for the bike frame. Once that's decided, the paper should be cut into six strips—one-quarter inch wide and six inches long. These will have to be manipulated on the desk top in conjunction with the wheels and pedals until some semblance of a bicycle frame is achieved. You could help by showing a chalk drawing on the board in the following sequence (see Figures 2-9c, 2-9d, and 2-9e).

FIGURE 2-9c

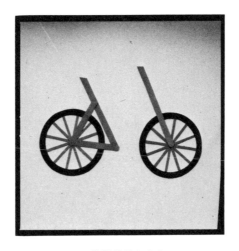

FIGURE 2-9d

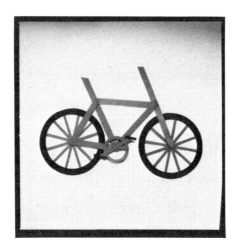

FIGURE 2-9e

Some of the colored strips will have to be trimmed down at certain places so that they fit properly; it is essential that you go very slowly here to avoid losing your students. After this much is glued together, only a black seat and curved grey handlebars need be added to complete a basic bike. If time allows, some students might be interested in adding accessories such as lights, horns, or baskets.

Instructions for making the people are given in lesson 5 of this chapter. When all those parts are cut out they will have to be assembled at first right on the bicycle so that feet reach the pedals, hands reach the bars, and arm and leg joints are bent in accommodation. The legs, of course, will be separated by the bicycle—one on each side. Things will look pretty weird at this point with all those unclothed figures seated on bikes, but don't rush anything, and be sure to check each child's work before he glues it together, since it's much easier to correct mistakes at this stage.

Clothing the figures and delineating facial features can be done following methods discussed in the four lessons preceding this one. Yarn hair is especially appealing on these people. If it is frayed out in back, as though being blown by the wind, the illusion of movement will be strengthened and add greatly to the depiction of action.

DISPLAY There are several ways in which these bicycles can be displayed ranging from simple to complex. The easiest way would be to create a plain path above the chalk boards and bulletin boards around your room. Or let them run around the door frame on the outside of your room.

A more complete and decorative display could go along a hall wall in the form of a country roadway. Begin by counting the number of cyclists you have and cut that many pieces of 6" x 9" grey paper. Then cut double that number of slightly curved low hills or ground rises from two or three shades of green. Put up the grey end to end at a child's eyelevel, then a row of hills in back of it and another row in front. After the bicycles have been arranged on the roadway, trees and flowers could be added where color accents are needed. A few dried weeds or grasses clumped here and there would be enhancing.

The display shown in the photograph takes more time but is very striking. To duplicate this one, you will need twenty sheets of 12" x 18" green paper (five dark and fifteen light). Round them off by cutting random convex curves, without reducing the length of the paper to any great extent. These are taped up on the wall in a triangular shape which creates one large hill about eight feet wide at the base and six feet high. Start close to the floor and arrange a row of six light greens, overlapping them slightly. Diminish each row by one as you work toward the top. Put the grey roadway in slanting segments which parallel each other, if all bikes are heading in the same direction, or which angle each other, if all bikes are not heading in the same direction. The parallel version would make the roadway appear to be spiraling *around* the hill, whereas the angled construction would seem to alternate *up* the hill. At the top you might feature a shade tree or simply a sign with your grade and room number.

Variation

Have your students reinvent the wheel. How was the wheel first invented and by whom? Using cartoon form, this can be an interesting exercise in creative conjecture.

CHAPTER 3

IMAGINARY SCENES

LESSON 1

Exploring the Deepest Part of the Ocean

PREPARATION Before any work is begun on this project, you will need to create the "deepest part of the ocean" that is to be explored. Pick out a portion of wall space that is at least seven feet high and nine feet wide. When no one is looking, take a piece of chalk and draw a large oval within that space. Scallop one edge of sixteen pieces of 12" x 18" black construction paper in sea-wave shapes, as in Figure 3-1a.

Stack them and cut through as many as possible each time. Tape these scalloped black papers to the wall so that the points touch the chalk line (see Figure 3-1b).

FIGURE 3-1a

FIGURE 3-1b

Now fill up the inside of the oval with more paper until it is all solid black. (You'll have to trim some corners here and there to get it to fit.)

PRESENTATION Show this giant, black, unexplored hole in the ocean to your students and explain to them what it's supposed to be. Ask them to think about the kind of imaginary vessels which would be needed to take explorers to such a spot. Who would have designed them, how would they be shaped, what parts would they be made from, what function would they have? Then discuss the kind of explorers these "ships" would be carrying. What equipment would they take along; what would be the purpose of the mission? Finally, talk about creatures, things, and objects these explorers might find in this place—possibly a form of life never seen before involved in a very unique culture, or even funny imitations of our own. Objects used with an incongruous or anachronistic twist might be there.

Don't try to plan the entire scene or the spontaneity will be lost. Just be careful that each child doesn't try to do too much in a fit of over-ambition. Students may want to work in groups of two or three to create a vessel containing several people or creatures. Some may want to concentrate on a highly mechanized vessel and show it at one complicated stage of its function. Another group could work on a small coordinated scene showing the sea creatures in a common activity.

Specific suggestions could include: a submarine garage, bait shop (to catch fishermen), communications center, underwater carousel, sunken boats, portrait photographer for fish, fashion shop for aquatic monsters, sand-dollar bank, sight-seeing tour, a wishing well.

Before the actual working period begins, each student or group should make a plan or reference drawing and color it with crayon so that time and effort are not wasted or out of sequence. Scrapbox paper should be an adequate supply for most of this. The need for an occasional large piece of paper, which must come from stock, will be foreseen at the planning stage.

DISPLAY Cut several "sand hills" from grey paper. Place these in random groups on the lower half of the black oval so that the space is broken up laterally and some definition of bottom and top is implied. Lay out all the children's work on a table (or the floor) and determine which pieces should be shown in the sandy bottom of the display and which would look best in the top half. Fill in the top part first and let the objects overlap as you work downward. Some things will seem to group themselves naturally and others might benefit from trial and error placement. Let your sense of humor guide you.

Variations

I

If Outer Space hasn't become an overworked and trite subject for your students, you might use the black oval to represent a black hole in space and fill with appropriate exploration units.

II

Or, explore Inner Space. Choose one tiny spot on an ordinary object and blow it up to show what's going on in a microcosm. (See Figure 3-1c.)

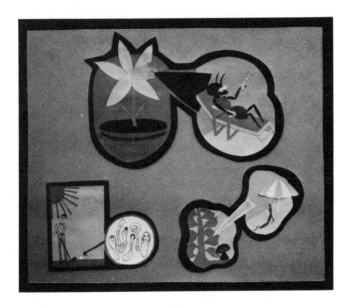

FIGURE 3-1c

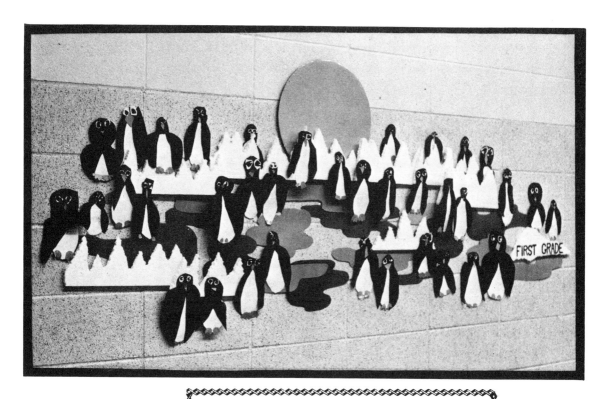

LESSON 2

Penguin Party

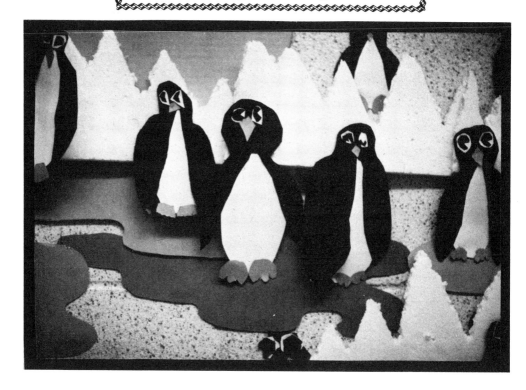

Penguins are an especially good subject for primary-grade children to draw, and they experience great success with them too. But older students are also interested in these birds and enjoy the simplicity of their construction and the entertaining display which results.

PREPARATION Each child will need three pieces of paper: one piece each of 6″ x 9″ black, 6″ x 9″ white, and 3″ x 3″ orange. (Use the same colors yourself for demonstration but in proportionally larger sizes.) If you can find some flat sheets of styrofoam packing material, they will make terrific icebergs for the display and for motivating the students.

PRESENTATION Put up an iceberg or two at the front of the room. If you can't find a sheet of styrofoam, crack up some white styrofoam drinking cups into jagged points and tape them together at the back. Talk about the Antarctic environment of penguins and discuss the subject to the extent you deem suitable for your class. Many films are available, as well as television presentations, with which the project could be easily coordinated.

Begin to make the birds with an oval shape drawn on the white paper. As soon as it is drawn satisfactorily, have each child write his name in the middle. This will serve not only to identify the artist, but also will help later when the parts are being fitted together. Cut out the oval and place it on the black paper, name-side up. Trace around the outline with white crayon and set aside. The head and wings can now be drawn on top of the oval to assure a perfect fit. Use an orange crayon for this part, to avoid confusion later on, and cut it out (see Figure 3-2a).

FIGURE 3-2a

Start to cut on the orange line at the place where the head joins the wing. Cut up around the head and stop when you get to the other wing. Make sure everyone understands which direction the scissors are to take from this point on, or you might have a few tearful disappointments. If it is understood that the head and wings will all be in one piece after they are cut out, success is more certain.

Fold the orange paper in the middle, draw the beak on the fold, and the foot just below (see Figure 3-2b).

FIGURE 3-2b

Stack two scraps of white paper and cut dime-sized circles for the eyes, then color a large dot in the center of each with black crayon.

Begin to assemble the penguin by turning the black head-wing section wrong side up on the desk so that the original outlines of orange and white crayon can be seen. Apply glue inside the *white* line and then place the white paper oval, name-side up, on top of the glue. Press gently and flip the figure over to the clean side. Glue the eyes and beak in place and finish by adding the feet.

DISPLAY The Antarctic setting for these penguins could be successfully carried out in black and white with only the orange accents of the beaks and feet showing color. This would present a welcome sight during some of those hot days of fall or spring, and to put it up, as such, you would only need several balanced rows of icebergs with the penguins perched upon them.

However, if this display is going up on the wall in the middle of winter, it should have more color plus a large sun to warm it up. Shape the icebergs from the styrofoam which should be cut, with a knife, if it's more than one-quarter inch thick, making jagged points right across the

middle of the sheet so that you will get two icebergs from each (see Figure 3-2c).

You will need one iceberg for every six penguins. Cut sixteen colored free-forms from magenta and orange paper, as in Figure 3-2d.

FIGURE 3-2c

FIGURE 3-2d

Tape these to the wall alternating the colors as you go. Start at your eyelevel and define an oval space with them.

Put a row of icebergs across the top, then scatter the remainder in pairs throughout the colored water. Finish with two or three at the bottom.

Sort the penguins into three size categories. Put the smallest on, or slightly in back of, the top row of icebergs. The birds should be in small groups allowing spaces for the water and ice to show in between. Continuing in this way, place the middle-sized penguins in the center of the display and the largest ones at the bottom.

A large twelve-inch diameter sun tops the display. Make it of orange paper (better yet of orange cellophane if you have any) and tuck it down slightly behind the top center iceberg.

Variations

I

Make the penguins on a much smaller scale and enclose each in a plastic container as described in the Chapter II *Greenhouse* project. Tape sixteen units to the wall in rows of four each to form a large simulated

ice block. Then surround it with a giant pair of black paper ice tongs (Chapter 5, lesson 5), as in Figure 3-2e.

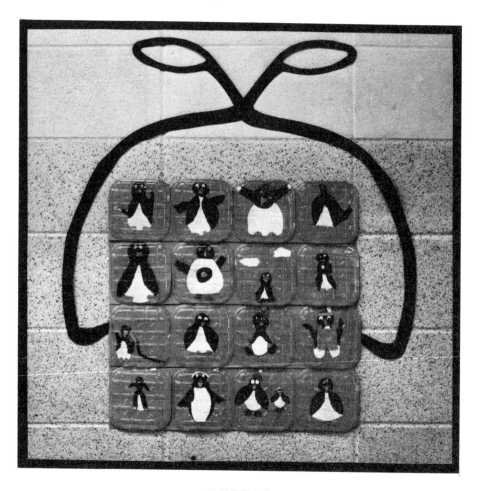

FIGURE 3-2e

II

Suggest that the basic penguin figure be changed to show movement. Unify all in one common activity such as ice skating. (See Figure 3-2f.)

III

Go a little further and create a "snowbow" with colored tissue snowflakes. Then put bluebirds above it to raise morale and provide some hope at the tail end of a long and dreary winter. (See Figure 3-2g.)

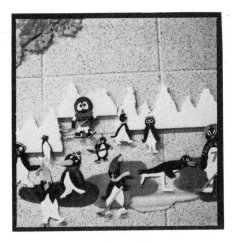

FIGURE 3-2f

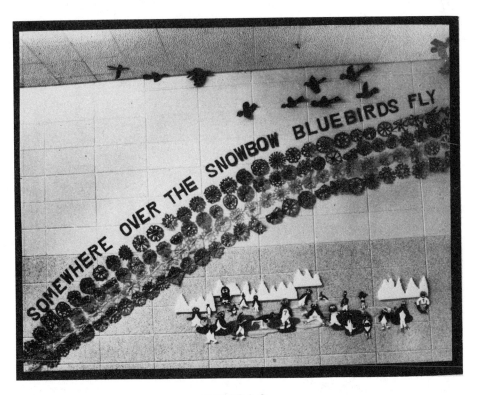

FIGURE 3-2g

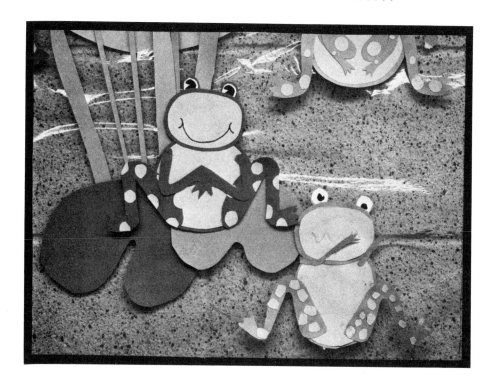

These frogs are a breed unto themselves. They look like eager show-offs and will provide a display which you can expect to be enjoyed for many weeks.

PREPARATION Make a frog yourself before starting the project with your class. This will give you more confidence when you present the lesson, and it will aid in motivating the class if you have something concrete to show them before they begin. On 6" x 9" yellow construction paper draw a large circle and a large oval. Then, wherever you can fit them in, scatter ten dime-sized circles (see Figure 3-3a).

After the parts are cut out, glue the large circle and the oval to one half of a 9" x 12" piece of orange paper. Cut them out again leaving an edge of orange, about one-quarter inch wide, showing all around each. Fold the remaining orange paper in half and draw a leg plus two different styles of arms, as in Figure 3-3b.

FIGURE 3-3a

FIGURE 3-3b

From a small piece of white paper cut out two three-quarter inch circles and glue them to the orange wherever there is room. These are to be the eyes. Cut them out again leaving an orange edging around each and crayon some black dots in their centers.

Assemble the head (yellow oval plus eyes) and draw some sort of a line for a mouth with orange crayon or marker. (See Figure 3-3c.)

FIGURE 3-3c

The eyes go in back of the head, and you should experiment with several different versions of the mouth before you finalize it. You may be surprised to discover how the expression can be completely altered by the length of the line, the number of curves or straight lines involved, and the upward or downward thrust at the ends.

Glue the yellow spots to the legs, then position arms and legs on the body. Don't fasten them in place until you have tried several positions. Legs start at the base of the body and flare outward at an angle, but the arms are more expressive. They can be reversed, combined (one from each set) or used symmetrically. Again you will discover how one small change can alter the personality. When you've got it finalized, tape it together. Don't glue it because you'll be taking it apart later.

PRESENTATION Pass out the paper: a 6″ x 9″ yellow, 9″ x 12″ orange, and 3″ x 3″ white. Show your model frog to the class and then take it apart and demonstrate how different it looks when you vary arm structure and mouth line. (Put your mouth variations on additional yellow ovals—same size as the original—and simply fasten them on temporarily with tape).

Direct the students through the process slowly. Put the cutting diagrams on the board as you proceed. Or you may prefer to make actual demonstrations using very large pieces of paper.

Encourage experimentation with mouths and arms before the figures are finalized and glued. Have on hand some extra half-sheets of yellow and orange paper for quick distribution to the I-just-got-a-better-idea geniuses.

DISPLAY Cut four waterlily pads from orange paper. Tape one to the wall at the very center of the space you've chosen for your display. Fashion a large piece of amber cellophane into a curving pond and fasten it to the wall with plenty of masking tape. The lily pad will show through the middle. Since the cellophane will bear most of the weight of the entire display, apply tape in lengths (rather than circles) at various places around the edge. Conceal the tape with the remaining lily pads and a few frogs. Make six brown hot-dog shapes for cattails and glue them on top of twelve-inch yellow stems. Place these in groups rising out of the water and surround them with some long, yellow, pointed leaves. Emphasize the center grouping of reeds by placing a large white moon directly in back of them.

Cluster the frogs around the edges of the pond, on top of the lily pads, and in front of the cattail bases. Since each one will want to be the star of the show, not much overlapping will be possible. If you run out of pond space, tape more lily pads beyond the sides for additional seating.

The color scheme could be pleasantly varied by substituting red and pink paper for the frog construction instead of orange and yellow. Magenta and lavender work well together too. Or you might like to combine all of these and use pink cellophane for the water.

Top off the display with a few dragonflies which can be made by students who finish their frogs before the rest of the class.

Variations

I

Turn the frog group into an orchestra, complete with a conductor plus varied musical instruments. The instruments would be made before arm positions are determined. (See Figure 3-3d.)

II

Instead of the instruments, put music in the frogs' hands and they become a "Brek kek kek koax koax" choral group.

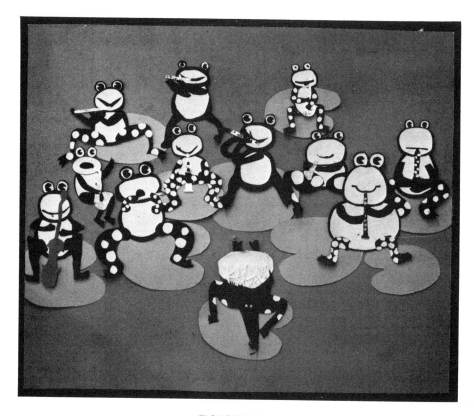

FIGURE 3-3d

LESSON 4

Happy Hippos

Hippopotamuses have tough leathery hides. As subject matter, they provide an opportunity for emphasizing the importance of textural differences between animal skins.

PREPARATION Papier-mâché produce trays from the supermarket are the perfect kind of material for this lesson. They are usually manufactured in two colors (purple and green), and a variety of sizes and shapes. Start collecting the purple ones, and ask your friends too—people love to save these things. When you have accumulated enough material to provide each child in your class with the equivalent of an 8" x 8" piece of paper, you are ready to begin.

PRESENTATION Pass out the material and call attention to its roughness. Talk about hippopotamuses and their ancestral relationship to prehistoric animals. The size and weight of the hippos of today are of great interest to children, and the awkwardness of their movements, due to their short legs and clumsy feet, makes them appealing. If possible, share with the class some photos or drawings of these creatures in their natural environment.

Show an outline drawing on the chalkboard of the shape of the body. It is pear shaped and should be reproduced by the children on the pieces of material that would best accommodate the size. (See Figure 3-4a.)

The head should be drawn next wherever there is room, and of course it should be in proportion to the body. (See Figure 3-4b.)

Cut out the head and place it on a fresh area of the cardboard. Trace a shape slightly larger than the head for the neck, so that the neck

FIGURE 3-4a FIGURE 3-4b

will appear to surround the head when the unit is assembled, as in Figure 3-4c.

FIGURE 3-4c

The stumpy legs with attached feet along with ears and tail can be drawn on the remaining scraps of cardboard. (See Figure 3-4d.)

Several pairs of heavy-duty scissors should be available throughout this project, because some children may experience difficulty in cutting such thick material with standard student scissors.

Finish the face by adding nostrils with black ink (or dark #2 pencil) and two white ticket-punch eyes. These will be glued in place and detailed with ink or pencil lines. (See Figure 3-4e.)

FIGURE 3-4d

FIGURE 3-4e

Leave the assembling of the hippopotamuses for the end of the day when they may remain on the desks for at least an hour, undisturbed.

DISPLAY Cut the tops of twelve large pieces of yellow paper into water waves, as in Figure 3-4f.

Tape these to the wall in horizontal rows of three or four pieces each.

Make ten lavender land-mass shapes and arrange them so that they surround the water.

Plant a palm tree on each island. Magenta is a good color for the trunks and purple for the leaves. You should have a set of five 3-inch long leaves for each seven-inch trunk. (See Figure 3-4g.) Emphasize the nodes on the trunks with purple crayon lines.

FIGURE 3-4f

FIGURE 3-4g

The hippos can be placed in the water and on the land masses wherever they show up best. They could be munching on some remnants of your dried weed collection (just poke little bits and pieces gently into the mouths). Additional weeds in random clumps would also enhance the islands.

Variations

I

The rhinoceros is so similar in shape and texture to the hippopotamus that it can be made in almost the same way and with the same materials. The head would be best viewed from the side, and the

horn could be made of scrap plastic. The rhinos in Figure 3-4h were grouped and displayed with silver daisies just for fun.

II

Dinosaurs too are interesting subjects to be produced with this material. (See Figure 3-4i.)

FIGURE 3-4h

FIGURE 3-4i

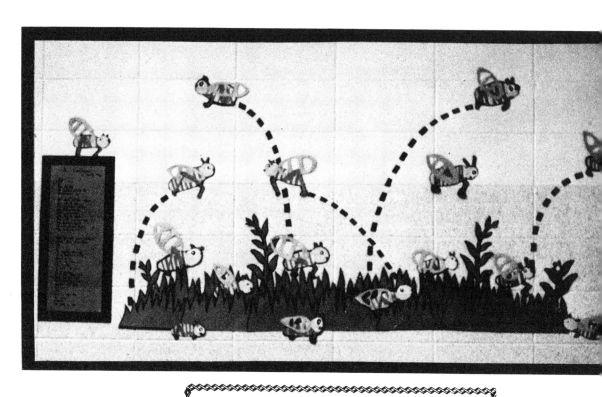

LESSON 5

Grasshopper Hop

PREPARATION These grasshoppers have a cartoon-like quality to them which lends itself nicely to a wall-size illustration. Find a poem about grasshoppers and read it to your class. Later, copy it on a large piece of lavender construction paper so that it will be ready to put up alongside the display.

You will need three shades of green paper for each student. Cut the *light* green into 4½" x 12" pieces. The *medium* green should be 4½" x 6", and the *dark* green 4½" x 6" also.

Prepare some lavender paper: 6" x 3" and a smidgeon of purple about 2" x 3".

You will also need small scraps of black and white. (An inch square of each will be exactly enough if you want to cut it that small.)

PRESENTATION After reading the poem aloud to the class, pass out the light green paper on which the head and body are to be drawn (see Figure 3-5a).

Distribute the medium green paper and demonstrate how to cut it into thin curving lines, as in Figure 3-5b.

Glue these to the oval body to create a striped effect, trimming where necessary (see Figure 3-5c).

FIGURE 3-5a

FIGURE 3-5b

FIGURE 3-5c

Pass out the black and white paper for the eye, then go around the room with a ticket punch and a large scrap of white paper and deposit one white punched-out circle on each desk. Be sure this is glued immediately to the black paper so that it doesn't get lost. Demonstrate the eye structure with some large pieces of black and white paper so that all can see.

Cut a black oval around the white dot, as in Figure 3-5d.

Glue the black oval to the middle of the white paper and cut a larger oval around it to complete the eye. (See Figure 3-5e.)

FIGURE 3-5d FIGURE 3-5e

Fasten the head to the body and glue the eye in place, as in Figure 3-5f.

Switch to the dark green paper and draw the front and back legs. (See Figure 3-5g.)

Fold the lavender paper in half lengthwise and draw and cut out a gauze-like wing (see Figure 3-5h).

FIGURE 3-5f

FIGURE 3-5g

FIGURE 3-5h

FIGURE 3-5i

Assemble the grasshopper, then add three finishing features: a small black oval nose, two dark purple oval feet, and green antennae (see Figure 3-5i).

DISPLAY Cut seven sheets of medium green paper into grass clumps, two from each sheet. Glue these to black paper and cut out again leaving a black edge all around.

Tape the grass along the wall in two overlapping rows. Intersperse three or four plants (also black-edged), and then arrange the grasshoppers. Put half of them in the air above the grass in various stages of jumping. The remainder can go in between the grass clumps and the plants.

Cut some curved strips from black paper. The strips should be a half-inch wide and as long as the paper. These will be used to amplify the cartoon-like appearance of the grasshoppers and will help to convey the idea that they are jumping. Time and patience will be needed here, but the effect is worth it. Cut the black curves into one-inch segments and fasten a small circle of tape to the back of each. Put them on the wall so that they define an arching broken line with a grasshopper at the end. These lines can cross each other occasionally without losing direction. It's a little easier to cut a few segments at a time, then tape them up in sequence rather than to work with a large quantity at once. Also, you might find it helpful to draw a curve on the wall lightly with chalk to serve as a guideline.

Matt the poem you copied earlier on black paper and put it up next to the display. A small grasshopper could be perched right on top.

Variation

Since the grasshopper, in fables, is known to be a carefree creature fond of playing the violin, your students might adjust the positions of their insects and add instruments to create a unique string ensemble. (See Figure 3-5j.)

FIGURE 3-5j

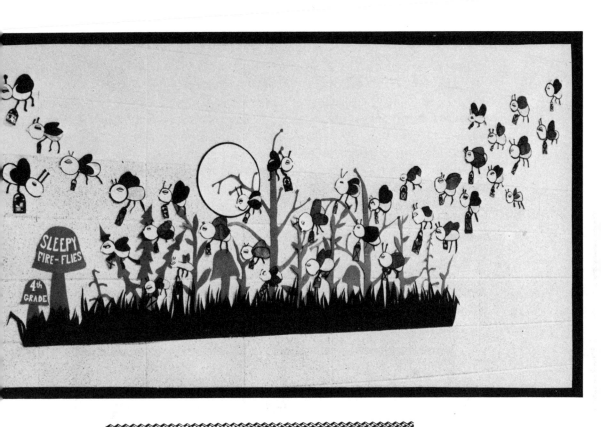

PREPARATION An odd assortment of scrap materials goes into this project and will need to be collected in advance. The list includes: a small-meshed net onion bag, orange "satin" finish gift-wrap ribbon (one inch wide), and silver foil chewing gum wrappers.

Each child will need specifically: a 9" x 12" piece of black construction paper, 2" x 2" yellow, 1" x 1" white, 1" x 1" grey, 1" x 1" bright orange, 2" x 3" silver, and a 1½ inch segment of the ribbon.

These fantasy fireflies might be difficult for the children to envision, so make a model in advance of the lesson to show to the class. Cut the circular head from the yellow paper and glue it to the black. Cut out again leaving a quarter-inch of black edge showing. Place the small grey square on top of the white. Keeping them together, cut identical ovals from each. Glue the white oval to the black and edge very narrowly. Bisect the grey oval lengthwise and glue it to the black. This is to be the eyelid and lash. The black edging for this piece takes a different form (see Figure 3-6a). Make slashes along the bottom edge and bend them upwards to form the lashes. Cut a quarter-inch circle from the bright orange paper (pupil), then assemble the eye on the head. Try for a sleepy look. Various degrees of this can be attained by lowering or raising the position of the lid, as in Figure 3-6b.

FIGURE 3-6a FIGURE 3-6b

(It might be a good idea at this point to make up a giant-sized example of the eye for use in your demonstration later.)

Draw an oval on the silver paper—the largest size possible. Cut it out and repeat the black-edging process. This is the body—shiny to suggest a light source.

Cut two oval wings from the black paper slightly smaller than the body. Insert a small hardcover book inside the net bag and lay the wings on top of the bag. Peel the paper off a silver crayon, and using it

flat on its side, rub across each wing separately so that you pick up the texture of the net underneath. This creates a slightly shiny, gauzy effect. Back the wings with more black paper and edge them.

Draw three black legs about one-quarter inch wide and three inches long. Bend each one differently (see Figure 3-6c).

FIGURE 3-6c

The front one will be carrying a lantern and will need a hand-like projection.

Begin to construct the lantern by gluing the ribbon fragment to black paper and cutting it out to leave a very narrow (one-eighth inch) edge surrounding it. Fashion a handle, a chimney, and assemble (see Figures 3-6d and 3-6e).

FIGURE 3-6d FIGURE 3-6e

Add two thin strips as cross pieces on the front.

An oval silver nose fashioned from the scraps, and two small black antennae are the last pieces needed before you begin to assemble the firefly.

Start with the wings, fan them out slightly, one on top of the other, and glue them to the back of the head, as in Figure 3-6f.

Arrange the legs on the body (see Figure 3-6g),

and then fasten all together (see Figure 3-6h).

FIGURE 3-6f

FIGURE 3-6g

FIGURE 3-6h

PRESENTATION Now that the work is finished, you can have some fun with the class by showing them your firefly and inviting them to make up a story about it. You might suggest that he has been flying around all night lighting his light thousands of times and is now so tired and sleepy that he needs to use a lantern to find his way home. Or that he is looking for a place to sleep among the imaginary plants he is flying over. He might be helping to search for some magical lost article. Poems or stories with a great deal of charm could be written individually or collectively by the class members and displayed later along with the fireflies for other students to read.

If you don't want to get your class involved with fantasy, or if they are just too sophisticated for it, you might simply read a poem to them about fireflies such as Elizabeth Roberts' "Firefly," Robert Frost's "Fireflies in the Garden," or "Fireflies" by Dorothy Aldis.

The working part of the project should be broken up into at least two sessions so that it doesn't become too taxing. For an interesting variation of the lantern construction, use orange cellophane instead of the ribbon and enclose a miniature firefly made from leftover scraps behind the "glass."

DISPLAY Put up a long row (about five feet) of black grass shapes. Then scatter a series of dark purple plant and mushroom shapes all along the row (see Figure 3-6i).

FIGURE 3-6i

Cut two of each and place the tallest forms in the middle and the short ones on the ends.

Make a large, white, full moon, edge it with black, and center it in back of the tall purple plants so that they are featured in silhouette against it.

Start to put up the fireflies in hovering positions above and among the grass and plants. When that space is all filled up, start taping in-flight groupings to the wall on the right and left sides of the grass/plant area.

Spell out the display title plus your room number in yellow letters. Glue these to large purple mushrooms placed at one side of the grass. Frame poems and/or stories on purple construction paper and tape them to the wall in rows beneath the display.

Variation

Shorten the insect body and add some stripes. Omit one leg, and substitute fabric or wallpaper for the textured wings. This produces some very colorful and unusual bees which look most attractive when flying toward a vertical, flower-filled trellis. (See Figure 3-6j.)

FIGURE 3-6j

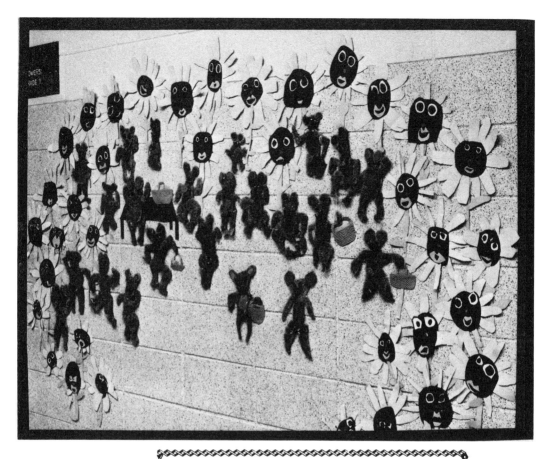

LESSON 7

Teddy Bears' Picnic

Even though it looks complicated, this project can (and has) been done by first and second graders. Therefore, the skill-level requirements are not great, and the bears can be successfully made by any class interested enough to try.

PREPARATION You will need a large quantity of fuzzy brown carpet padding scraps. A square foot for each child (or that equivalent in smaller pieces) will be adequate. If you don't happen to have any of this in your miscellaneous scrap-material boxes, ask the manager of a carpet store how to get some free remnants. With heavy scissors, cut the padding in nine-inch-wide strips, then pull it apart to expose the fuzzy inside. This operation produces twice the surface quantity you started with, and all of it will be fuzzy. The material will also be a lot thinner and therefore easier to cut when the time comes to divide it into the number of pieces necessary for your class.

Find a package of 12" x 18" light brown paper and be sure it is a different shade than the carpet padding. Also have available a square inch of silver foil paper and a two-inch segment of black yarn for each child.

PRESENTATION Pass out the carpet padding and encourage the children to examine its texture. If you had time to make an example of a teddy bear in advance, show it to the class and point out the ways in which it is similar to a toy. Explain that this is to be an imaginary social event involving unreal, but active, teddy bears. This "social event" can be anything you want it to be, depending upon the time of year and/or the particular interests of your students. However, if someone suggests a picnic, you're off to a good start.

Pass out the light brown paper and tell everybody to fold it in half. Put this diagram on the board (see Figure 3-7a).

FIGURE 3-7a

The pieces should be cut out right away (keeping the paper folded) so that there will be two of everything. (Even if you've already made a teddy bear as an example, you should work right along with the class and demonstrate.)

Turn the fuzzy side of the carpet padding face down, then start to glue the paper pieces to the smoother side. Fit them on to conserve space. Point out that one arm and one leg must be reversed, as in Figure 3-7b.

Leave these pieces in place to dry and return to the remaining brown paper. This time it should *not* be folded because you are going to need only one of each of these parts (see Figure 3-7c).

FIGURE 3-7b

FIGURE 3-7c

Cut them out and glue to the carpet padding wherever there is room.

On the remaining brown paper, draw two eyes the size of a penny. Color heavily with brown crayon and then color the centers black. Draw a triangular nose shape with rounded corner (about the same size as one of the eyes) and color it heavily with black crayon, then set that paper aside for awhile and begin to cut out all the fuzzy pieces (around the glued-on brown patterns) which should be dry by now.

This particular cutting operation takes a lot of time and effort. It simply cannot be managed with the small standard "art" scissors students have, so you will need to decide in advance either to borrow several pairs of large heavy duty scissors to be shared, or to schedule the help of student aides who can give the necessary assistance to each child in turn.

Place each piece fuzzy side up, arranging them in such a way that they can be easily identified (see Figure 3-7d).

Cut an oval from the remaining brown paper and make it one size smaller than the stomach oval. Glue this on top of the fuzzy oval. Cut two small brown paper ear circles and glue them to the fuzzy ears in the same way (see Figure 3-7e).

FIGURE 3-7d

FIGURE 3-7e

Set these aside to dry and return attention to the eyes and nose.

When these three items have been carefully cut out, pass out the silver foil squares and the black yarn pieces. Two thin wedges are to be fashioned from the silver paper and glued to the eyes, as in Figure 3-7f.

FIGURE 3-7f

Place the point at the center and trim the excess foil at the perimeter. It takes time and patience to do this and provides excellent training for children of all ages.

Glue the eyes and ears to the head and experiment with positioning of the yarn in the mouth area (see Figure 3-7g).

FIGURE 3-7g

Trim the yarn, if necessary, so that it will fit and then place a continuous line of glue on the face where the yarn is to be fastened. Carefully poke the yarn into the glue with a pencil point—avoid gluey fingers—then fix the black triangular nose on top.

Before fastening the figure together, experiment with positions of arms and legs. These will be influenced by the activity in which the bear is engaged such as running, walking, jumping, or carrying an object. As the attitude is finalized, the pieces should be glued at the contact points and then left completely undisturbed for an hour or more.

Any accessories can be fashioned at this time. Wood-grained wallpaper makes a dandy picnic table. Separated corrugated cardboard sheets are good for picnic baskets. Fabric can be used for tablecloths and basketcovers. Since this part of the project requires very little instruction, it could be completed independently by students during free time.

PART II: Sunflowers

Sunflowers are a great accompaniment to the teddy bears. If you're not in a great hurry to display the bears, store them away for a few days and devote another art period to these personified flowers.

PREPARATION Cut a 6" x 6" square of brown paper for each student. If possible, let it be a darker brown than that used for the bears. Also prepare 4½" x 6" black, 3" x 3" pink, 9" x 12" yellow, 6" x 9" light green, and 3" x 3" white paper for each student.

Make an example yourself first so that you are familiar with the procedure and can better judge how to present the project.

First draw a circle on the brown paper as large as the space will allow. Then in two of the corners, draw circles about the size of a quarter (see Figure 3-7h).

Cut these out and set aside. Fold the yellow paper in half lengthwise and draw six petal shapes (see Figure 3-7i).

FIGURE 3-7h

FIGURE 3-7i

Keep the paper double as you cut to produce twelve petals.

Place twelve dots of glue around the edge of the large brown circle. Position them as you would the numbers on a clock face to assure evenness and fit, then push the petal tips into the glue. Let this arrangement rest awhile and work on the eyes.

Glue two black ticket-punch dots to the centers of the small brown circles. Glue these to the white paper and cut out again leaving an even white edge showing all around. Glue these to the black paper and repeat the edging process, then make a series of straight cuts toward the center around the periphery of the black (see Figure 3-7j).

FIGURE 3-7j

Fashion a mouth from the pink paper. Do it in two parts—upper lip and lower lip. Glue these to black paper and trim away the excess so that the mouth appears to be open, as in Figure 3-7k.

FIGURE 3-7k

Turn the flower over so that the glued petal area is on the back. Arrange the facial features on the front. Fasten them in place with glue and add an oval nose with yellow crayon.

Cut a sturdy straight stem from the edge of the green paper. Make three or five leaves and alternate them along the stem, then secure the flower at the top.

PRESENTATION If your students are very young, you might want to present the sunflower in two work sessions rather than just one. You can decide how many sessions would best suit your class as you are preparing your example. The eyes and mouth are the most interesting parts of this flower, so it would be best to go slowly and get them finished just right.

DISPLAY Apply circles of masking tape to the backs of half the number of sunflowers and arrange them in an arch on the wall. Begin in the middle of the proposed arch (at your eye level) and add to the sides alternately until you run out of taped flowers. Put up the remaining flowers in a second arching line just inside the first one; place them wherever they fit best, overlapping petals slightly without concealing the faces. Cluster several at the lower ends of the arch.

Put the picnic table in the center of the empty space defined by the arch of sunflowers. Then add the bears one at a time around the table. Work outward from the center so that the last few bears will go in between the sunflower stems. Picnic baskets and/or other accessories related to the activity can be added at random wherever they most enhance the display.

An accompanying sign might announce title, grade, and room number. Or you might wish to omit the title and let viewers guess for themselves what the display is all about.

Variation

Omit the stems from the sunflowers and arrange them in a huge circle on the wall. Fill up the space inside with simple sailboats floating on a golden sea beneath a large cellophane sun. (See Figure 3-71.)

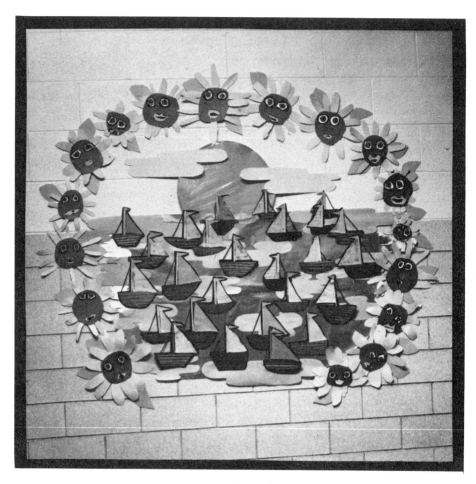

FIGURE 3-71

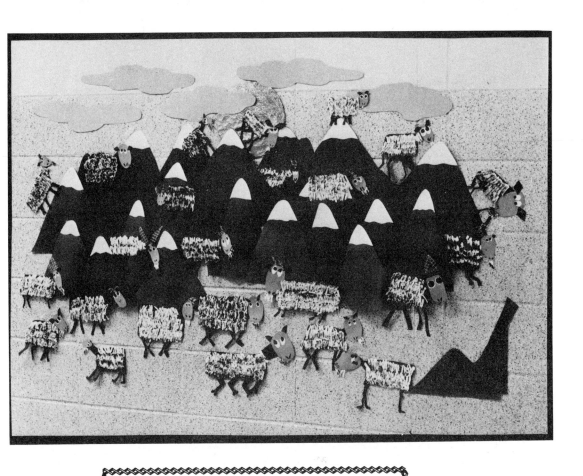

LESSON 8

Mountain Goats

Versatility is the major feature of this project. It can be mastered by any age group, appeals to any age group, and can be scheduled for any time of the year.

PREPARATION You will need a handful of plastic packing material for each student. It should be the long stringy variety, since it will be used to represent the shaggy texture of mountain goats' bodies. However, just about any form of this material can be used if it is first cut to the desired shape. Students can do it easily with their scissors.

Since these goats are meant to be comically amusing rather than realistically representational, 9" x 12" purple construction paper makes an interesting color from which to cut the body—one sheet for each child.

You will also need to provide a 4½" x 6" piece of lavender paper for the head, plus scrap plastic sheets for horns, and also a single jar of purple tempera paint with a few #3 brushes.

PRESENTATION Pass out the purple construction paper and explain to the class that this is to be converted into a funny mountain goat. You might like to discuss briefly the qualities of the real goats, such as their ability to navigate narrow mountain paths (as it relates to hoof and leg structure), plus the shaggy coats they grow to keep themselves warm in the low temperatures which prevail at high altitudes.

Draw a sample body on the chalkboard to help the students get started. Tell them to experiment with different leg angles and with placing the hooves in varied positions (see Figure 3-8a).

FIGURE 3-8a

Distribute the lavender paper. On this is to be drawn a simple oval for the head; the size of it should relate to that of the body. Add eyes and

nose markings to the head with white and black crayons, as in Figure 3-8b.

FIGURE 3-8b

Or use black and white paper for these features if you can take the extra time. Cut some purple paper ears from the leftover body scraps; glue these to the top of the head, positioned far enough apart to save room between them for the horns. The hooves may be colored black with crayon. (Take care that the paper doesn't tear during this operation.)

The bodies are now ready to be covered with the plastic "fur." Patience and time will be needed here, so you may want to schedule this phase of the project for a separate art period.

After the plastic packing material has been distributed to the students and they have cut it into thin one-inch long strands, demonstrate how it is to be applied to the body in overlapping rows. Begin at the bottom and apply parallel lines of glue across the lower part of the body about an inch above the tops of the legs. Then lay the plastic strands across the glue lines, as in Figure 3-8c.

When the plastic is in place all along the bottom, apply two more lines of glue for a new row just above and place the plastic strands for the second row so that they overlap the tops of the first (see Figure 3-8d).

After the entire body is covered, it should be set aside for at least an hour. The plastic will not actually be stuck until the glue dries. Mean-

FIGURE 3-8c

FIGURE 3-8d

while, working on the back of the head, apply more of the plastic strands to the chin for a beard. Complete the head by adding the horns. These are cut from the plastic sheet scraps and can be shaped

with extravagant curliques or simply curved to points. The horns will have to be taped to the back of the head (at the top and between the ears) because glue will not stick to this material.

Finally, a small amount of purple tempera paint should be lightly brushed over the "fur" to emphasize the texture and unify the piece. The children might take turns working in small groups with the paint.

DISPLAY Cut some pointy mountain tops from 12" x 18" magenta (or purple) paper, then top them with white snow caps. You will need at least eighteen of these. If you happen to have a large sheet of pink foil (salvaged from a gift plant), cut it into a twelve-inch circle for an unusual sun and make five pink construction paper clouds to go with it.

Attach a row of six mountains to the wall with masking tape at child's eyelevel and add two more rows overlapping the first, working downward on the wall. When you run out of mountains, place the sun and clouds above all, and then begin to position the goats. Tape them between the mountains or on the peaks or sides depending on the pose and personality of each individual goat. Cluster the rest along the bottom of the display along with a sign which announces your grade and room number.

Variation

Apply the same plastic materials and methods to create shaggy dogs. (See Figure 3-8e.)

FIGURE 3-8e

CHAPTER

(4)

PROJECTS WITH AN UNUSUAL POINT OF VIEW

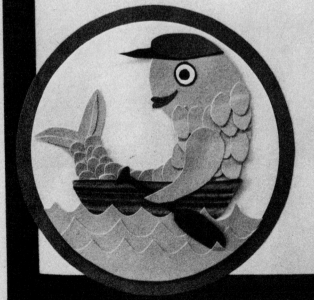

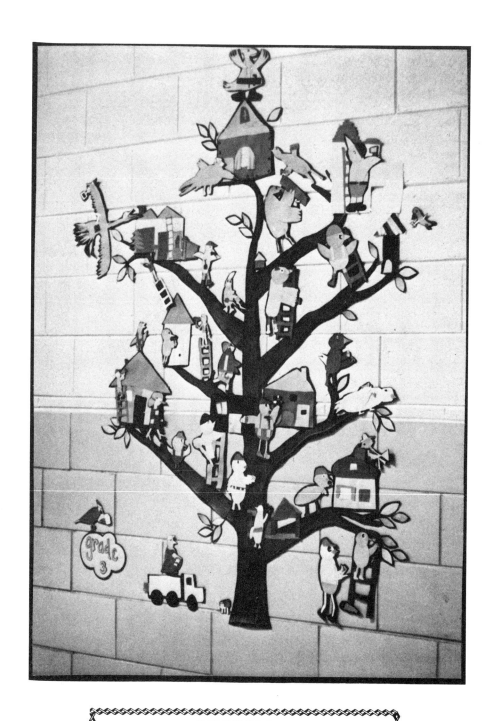

LESSON 1

House-Building Birds

PREPARATION Very little preparation will be necessary for this lesson. Several different colors of 9"x12" construction paper should be available plus black for backing. Any additional paper needed can be taken from the scrapbox.

PRESENTATION Discuss with your class the fact that birds build their nests from straw and grass and string and sticks. But what would it be like if they used boards and glass and nails and hammers instead? Would they still put these nest-houses in trees? Would they design them themselves or hire an architect? Would the materials be delivered by truck? Perhaps several birds would prefer to collaborate on one large house. Would the carpenter-birds wear anything special? Would they need ladders?

As the discussion is progressing, work may be started on the birds. Oval bodies, round heads, and wings can be cut from the 9" x 12" paper and then assembled by the students without teacher assistance. Beaks, eyes, and accessories can be fashioned from scraps. When each bird is completely finished, it should be glued to black paper and cut out leaving a black edge.

Set the completed birds aside and begin to make the houses. These might reflect the earlier verbalized suggestions as well as unique individual ideas. Again, the students can proceed independently, finishing the houses with black edging as they did the birds.

DISPLAY Cut seven or eight tree branch shapes from several sheets of 12" x 18" brown paper (wood-grained wallpaper samples are great for this if you happen to have some), as in Figure 4-1a.

FIGURE 4-1a

Fashion a thirty-six inch long tapering trunk from pieced-together brown scraps and tape it to the wall. Tape the branches in alternating horizontal positions until they reach the top of the trunk. The resulting tree form should have plenty of places available for houses and birds. Place these on the branches wherever they fit best. Put the larger houses and birds on the lower branches and work your way to the top. If the tree isn't big enough to accommodate all of the children's pieces, add a few branch extensions or new branches. If the tree seems too big, fill up the empty spots with spring green leaves.

Variations

I

More familiar versions of birdhouses might be cut from folded white paper and then decorated with roofs and windows. These can be displayed on a black circular background and surrounded by flowers and birds. (See Figure 4-1b.)

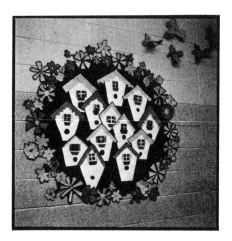

FIGURE 4-1b

II

Give each bird a miniature song book (a folded 1" x 2" paper rectangle), then arrange them all on the tree in choir formation. Add a director and pianist. (See Figure 4-1c.)

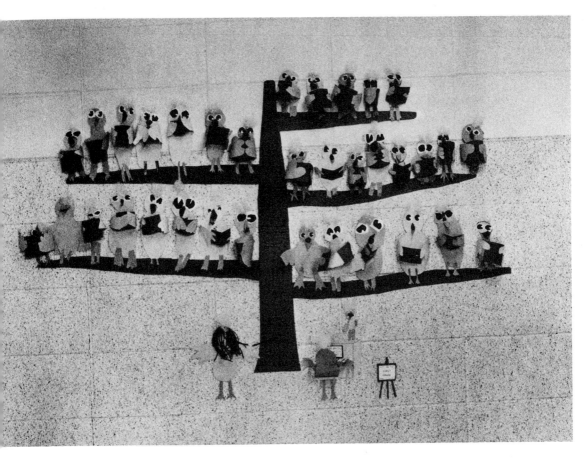

FIGURE 4-1c

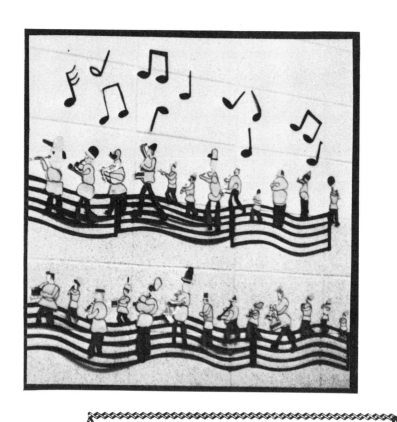

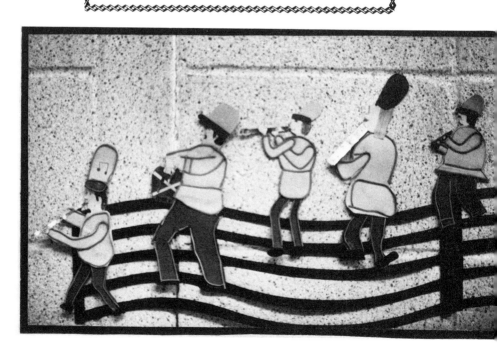

PREPARATION Count the rubber bands you've accumulated in your desk drawer and supplement the collection, if necessary, so that you have five rubber bands for each student. Select some 9" x 12" construction paper in two contrasting colors and cut the sheets into 4½" x 6" quarters (you might consider choosing your school colors). Every child will need one piece of each. Flesh-tone paper will also be needed for faces and hands along with small portions of a varied quantity of appropriate colors for hair.

Seek out some pictures of band instruments. (Ask the music teacher or the librarian, or look in mail-order catalogs). Then prepare very small pieces of black, yellow, and grey paper plus bits of gold and silver for the small instrument facsimiles which your students will be creating later.

PRESENTATION Distribute one of the colors of quartered paper to each member of the class and explain that this will be fashioned into the pants of a special kind of band uniform. Then pass out the rubber bands and let the children discover the double meaning of the project. Since the rubber bands are to be glued around the edges of the figure, it might be easiest to utilize the natural shape of the band, particularly where it bends, to achieve the appearance of marching legs. Suggest to the students that they experiment with the placement of the rubber bands on the paper. When satisfactory shapes are formed, the outline should be carefully drawn in pencil. Then the pants can be cut out and the rubber bands glued in place. (See Figures 4-2a and 4-2b.)

FIGURE 4-2a

FIGURE 4-2b

Trim where necessary. After the glue has been applied, the entire piece should be set aside to dry undisturbed.

Pass out the other color of quartered paper and instruct the class to place the rubber bands experimentally as before. This time they should

be attempting to form a jacket with arms which are carrying musical instruments. Show the pictures of these (if you were able to get any) or turn to the dictionary or catalog pages. Demonstrate how each instrument is held so that arms can be bent appropriately. (See Figure 4-2c.)

FIGURE 4-2c

When jackets have been set aside to dry, work can begin on the instruments. Display the pictures again and set out the foil papers plus scraps of black, white, and brown so that students may choose whatever they need for the particular instrument each has decided to make. This segment of the project takes at least half an hour, so you might want to begin a new session at this point.

After the instruments have been finished, combine them, in loose layout, with the uniforms. The flesh-tone paper plus colors for hair will be needed now. Heads and necks should be made in proportion to the uniformed bodies, then hands can be manufactured to hold the instruments. After hair is glued in place, hats may be fashioned using either leftover scraps (remaining from the uniforms) or small pieces of new paper (if this is being done in a separate session). Draw the style of the hat on the board so that some similarity of design will prevail.

DISPLAY Cut some one-quarter inch thick wavy lines from a 12" x 18" piece of black paper to make giant staff lines. (These will provide the base on which the band figures will be marching.) Start to make them by cutting a curve along the edge of the paper and then continue to parallel that curve at quarter-inch intervals. You will need forty of these lines for a class of thirty students.

Lay the lines out on a flat surface in sequence as you cut. As soon as you have five, space them three-quarters of an inch apart and attach straight strips at each end to secure the position. (See Figure 4-2d.)

FIGURE 4-2d

This creates one "measure" of the staff and will accommodate four marching figures. Repeat the operation until the staff reaches the total length you need.

Attach the staff to a wall by applying small circles of masking tape to the backs of the vertical strips. Then arrange the band figures in a row on top. Position the feet of the marchers so that they conform to the curves of the staff lines.

Cut some large musical notes from black paper and scatter at random above the display. Finish by adding two pennant shaped banners (held by some instrumentless marchers), which announce your grade and the project title.

Variations

I

Make the band uniforms entirely of red paper and substitute letters for musical instruments to spell out a seasonal message. (See Figure 4-2e.)

FIGURE 4-2e

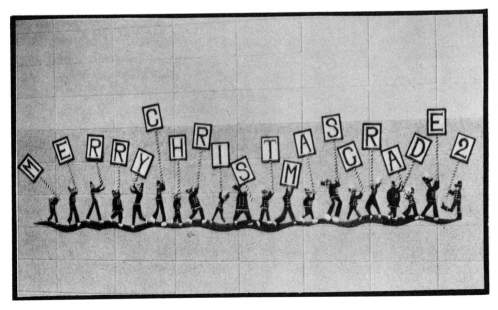

II

Use silver paper and create marching robots who are operating a fantastic machine. (See Figures 4-2f and 4-2g.)

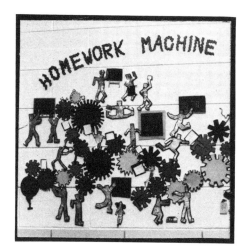

FIGURE 4-2f

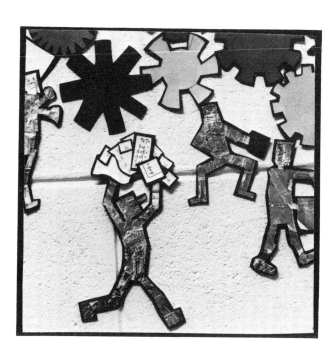

FIGURE 4-2g

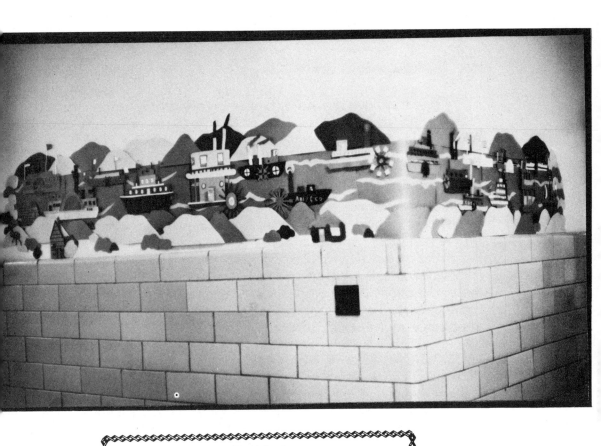

LESSON 3

Cornered River

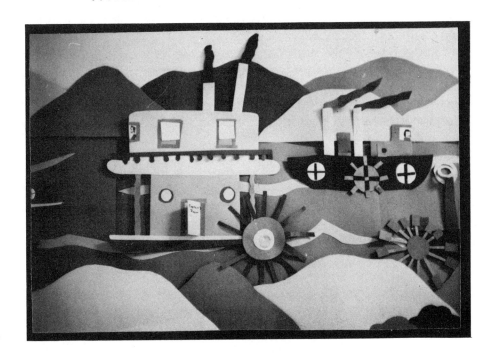

A river that flows around a corner is an eye-catcher since it really is different. Of course, if there is not a hallway or classroom corner available for display use, any straight wall will serve the purpose, but some of the novelty will be lost.

PREPARATION This project will need some prior class discussion about 19th century river travel on the Mississippi. Excerpts from any of Mark Twain's books would be appropriate for reading aloud, particularly *Life on the Mississippi*. Pictures of house boats, early steamships and river boats might be shown with an opaque projector. Find out if film strips or color slides are available on this subject in your district. But lacking any of these, dictionary illustrations would be useful to help the students gain some clear idea of the structure and function of these vessels and their importance to the development of our country.

PRESENTATION When interest in the subject is at its peak, invite the students to choose their favorite boats to be rendered as cut-paper pictures. Preliminary drawings should be made and colored with crayon so that a sequential working plan can be devised for each student. (Complicated structures might be collaborated on by two or more individuals if they can work successfully together.) Many students will be able to make the "blueprint" drawing and proceed almost unaided to the finished boat replica. Others will need help in deciding how much of which colors of paper to choose, what parts to cut first, and how best to assemble them. Since this process will require more than one art period, it might be best to store the work in individual folders so that the many separate pieces will not be lost.

Students who finish early can cut out some hill shapes from at least two shades of green paper (more if you have them). The hills will be used to define the river boundaries and you will need about forty of them: small ones for the far side of the river and large ones for the near side. Some trees and houses could be made at this time too.

DISPLAY Tape ten pieces of 12" x 18" blue construction paper to the wall and around the corner. Put up the small hills in an overlapping pattern along the upper edges of the blue paper. Large hills would of course go along the bottom, and the shades of green should be alternated. Place some extra-big mountains at each end of the river to create a "bay" effect and provide more graceful terminals to the display.

Students might place their boats where they want them, provided a big one in the foreground does not conceal the smaller ones in back. Trees, rocks, bushes, houses, docks, and people could be added for even further interest.

Variations

I

Put the people in small simple canoes rather than the larger elaborate boats. (See Figure 4-3a.)

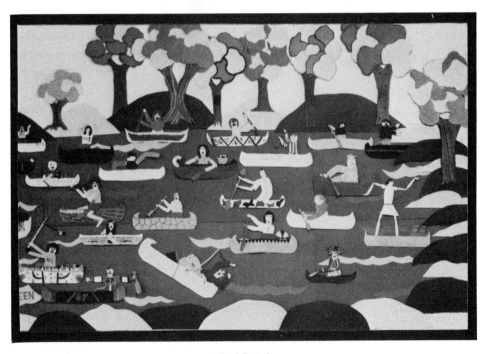

FIGURE 4-3a

II

Or substitute rowboats for canoes and simplify the figures of people. (See Figure 4-3b.)

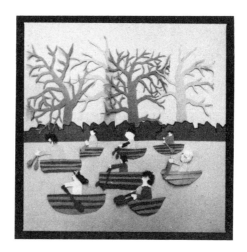

FIGURE 4-3b

Cold January days provide an interesting time to fantasize about summer picnics. Of course no picnic is ever complete without ants, and even the ants themselves might indulge in a few picnic reveries in January. They might even be planning strategy and practicing.

PREPARATION Make a two-dimensional woven picnic basket from two large pieces of brown construction paper. Stack the paper, fold in the middle, and cut the shape (see Figure 4-4a).

FIGURE 4-4a

Now separate the pieces. On one of them, make four vertical cuts, but stop cutting within an inch of the bottom (see Figure 4-4b).

FIGURE 4-4b

Cut the other basket shape into horizontal strips. Unfold and lay them down in sequence as they are cut (see Figure 4-4c).

FIGURE 4-4c

Now weave the basket together beginning at the bottom and working your way to the top. (See Figure 4-4d.)

FIGURE 4-4d

Secure the last strip with glue, then attach a handle. Search through your scraps for a piece of orange or yellow fabric. It should be large enough to cover the top of the basket. Puff it up under the handle and tape it in place.

PRESENTATION Develop with your class the fantasy of ants practicing for a picnic. Tape the picnic basket to the chalk-board. Ask the children to plot out such paths or underground tunnels as the ants might use in order to get to the basket. Pass out 6" x 12" black paper and 6" x 12" brown paper to each student. Put a large drawing on the board to show how the head, thorax, and abdomen should be formed, then cut out from the brown paper. (See Figure 4-4e.)

FIGURE 4-4e

Point out that the head and abdomen are essentially triangular while the thorax is oval. The three pieces should then be glued to the black paper leaving a bit of space between the parts. Two antennae and three legs are to be drawn on the black paper. Each leg is attached to the thorax and is bent three times. (See Figure 4-4f.)

The ants are ready to be cut out. Care should be taken not to cut off any of the extremities, and a black edge is to be left around the body parts, as in Figure 4-4g.
Pass out white ticket-punch dots for eyes, to be finished with a black penciled circle after they are glued in place.

At this point the class should be split into two groups: those who wish to make the "scenery" and those who want to make the various pieces of food for the ants to carry.

FIGURE 4-4f

FIGURE 4-4g

Provide the "scenery people" with 6″ x 18″ yellow paper, 6″ x 18″ orange paper, and black felt-tip markers. They should draw from memory or imagination some tall weeds and outline them with the markers. These drawings are to be cut out with a bit of the yellow paper showing all around the marker outline. (See Figure 4-4h.)

FIGURE 4-4h

FIGURE 4-4i

Glue them to the orange paper and cut out again, this time leaving an orange outline (see Figure 4-4i).

The effect is most striking, and even those students who are not particularly skilled in drawing will be pleased with the results.

The "food people" won't need much help. Just turn them loose with the scrapbox. The ticket punch comes in handy here to make holes in swiss cheese or pimento centers for olives.

DISPLAY Cut some curved strips from yellow and orange paper and organize them on a wall so that they represent the tunnels and paths for the ants. Place the picnic basket at the top. Put up the weeds at intervals along the paths and then line up the ants so that they appear to be either moving toward or away from the basket. Those moving away will, of course, be carrying the food.

Variations

I

Another nuisance-type insect that can be used as an amusing subject is the cockroach. Let each child create his own version (refer to dictionary pictures for help in drawing), and then add a costume. All of these can be arranged in an unusual ceiling display. (See Figure 4-4j.)

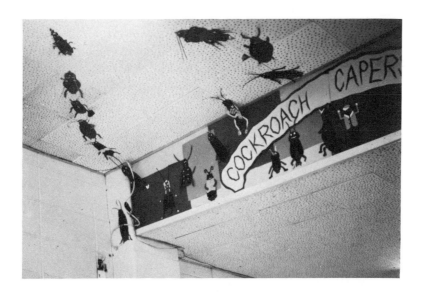

FIGURE 4-4j

II

Ladybugs are easy to make out of orange and black paper. (See Figure 4-4k.)

They look cute just walking up a wall all by themselves, as in Figure 4-4l, or they are fun when shown in conjunction with another display such as the hanging flower baskets. (See Chapter 6, Lesson 5, Variation I.)

FIGURE 4-4k

FIGURE 4-4l

III

Put sunglasses on any of the insects or bugs. Show some examples to your class. (See Figure 4-4m.)

Then add a few sand dunes and several towels and umbrellas to create a colony of "Beachbugs." (See Figure 4-4n.)

FIGURE 4-4m

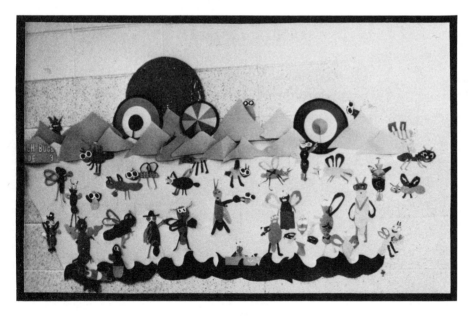

FIGURE 4-4n

LESSON 5

Fishbowl Condominium

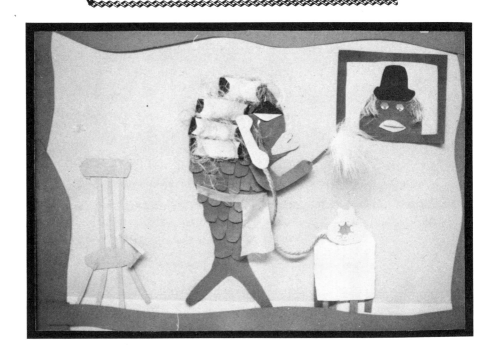

People who live in high rise condominium apartment buildings with glass walls often express the feeling that they are living in a fish bowl. It is interesting to pursue this idea with children, exploring the possibilities of fish living in this type building. The students will project influences from their individual environments and the finished products are quite unique.

PREPARATION Practice making a semi-three-dimensional "humanoid" fish. Cut the basic shape from 6" x 9" colored construction paper and allow the shape of the tail to suggest feet, as in Figure 4-5a.

Cut about two dozen ovals the size of your thumb and fold each one in half. Apply glue to the upper halves of the scales and attach in rows to the fish. Begin at the bottom and allow the lower halves of the scales to project outward for added dimension. The next row of scales will overlap and conceal the top of the first row. Continue to add scales until two-thirds of the fish is covered. The upper third will be the face. Make the facial features from colored paper. Hair can be string, yarn, or rope. Since the fins would function as arms, they would be shaped accordingly. (See Figure 4-5b.)

FIGURE 4-5a

FIGURE 4-5b

PRESENTATION After some discussion about glass apartments and the people who live in them, go to the idea of fishbowl condominiums and what fish would look like if they were to take on human characteristics. Each fish's living quarters would reflect his or her personality, occupation, and interests. They would at the same time retain fish-like characteristics. Let each child work out his own idea and sketch it briefly on notebook paper. Meanwhile, pass around your fish example so that the students can examine its structure individually.

Distribute 9" x 12" light blue construction paper. The color will connote water and the dimensions will be adequate for each child's composition. (You may want to go into a more detailed fish-making lesson at this point depending upon the age and skills of your students.) A variety of 6" x 9" colored construction paper should be available for the fish. Paper found in the scrapbox should be adequate for fashioning room furnishings and appointments. And any other odd scrap materials you happen to possess can be set out for use as finishing touches.

DISPLAY The finished display should look like a giant fishbowl which has many separate compartments. To achieve this shape, put up three rows of pictures, but use a plain piece of the light blue paper at each of the four corners (see Figure 4-5c).

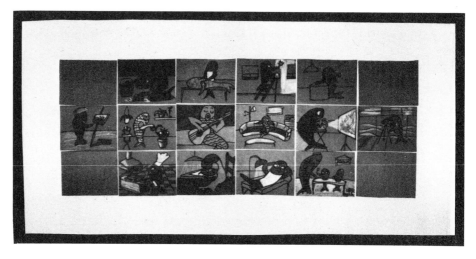

FIGURE 4-5c

From four sheets of 12" x 18" *dark* blue paper (stacked one on top of the other), cut four curved strips. (See Figure 4-5d.)

Tape the curved strips temporarily on top of the right and left sides of the display, then trace along their edges with pencil. This assures symmetry in shaping the sides of the bowl. (See Figure 4-5e.)

Remove the strips and trim the paper on the penciled outline, then reposition the strips and tape them securely in place. Cut some wavy strips from the dark blue paper. You will need four of them for each picture in the display. Tape them vertically and horizontally, partitioning each unit in its own wavy frame. Finally, cut some wide, straight, dark

blue strips to finish off the top and bottom of the bowl. You can print letters with marker across the top to identify the project as being a Fishbowl Condominium or make a separate sign to that effect and place it off to the side.

The display can be put up more quickly if you wish to forego the fishbowl shape. Simply put all the pictures in several straight rows to form a large rectangular fish tank.

FIGURE 4-5d

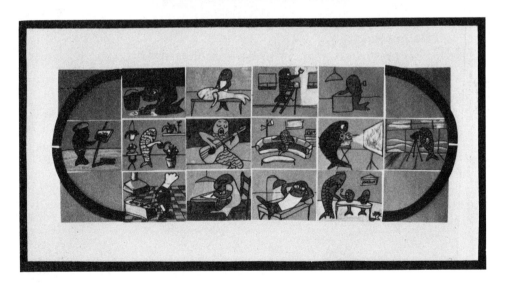

FIGURE 4-5e

Variations

I

Make the fish bodies a bit simpler and in a variety of sizes. Construct a large sign that implies an infinite regression (or progression), as in

Figure 4-5f, then arrange the fish around the sign in diminishing size order. (See Figure 4-5g.)

FIGURE 4-5f

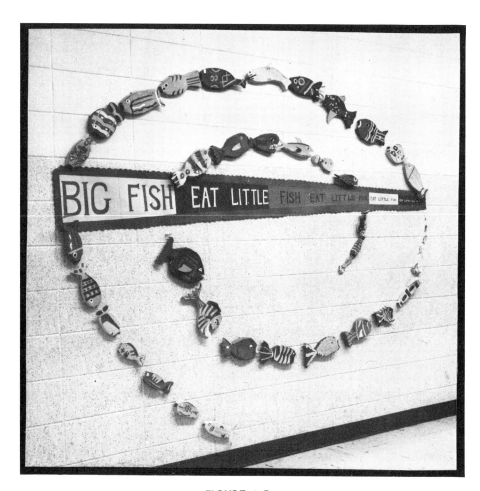

FIGURE 4-5g

II

Put each fish in a rowboat. Float them all on several bands of rippled blue paper backed with light blue clouds, and let them float across the wall in a strikingly different "fish race."(See Figure 4-5h.)

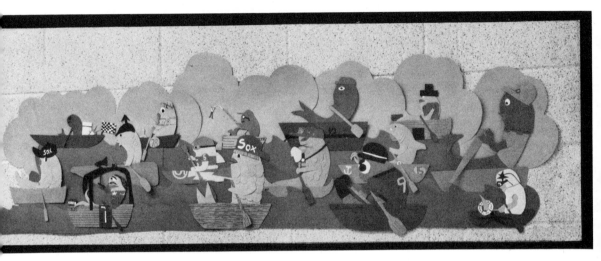

FIGURE 4-5h

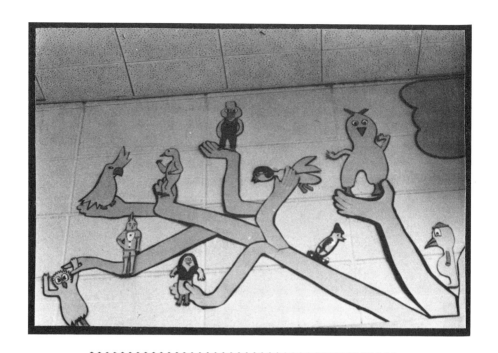

LESSON 6

A Bird in the Hand

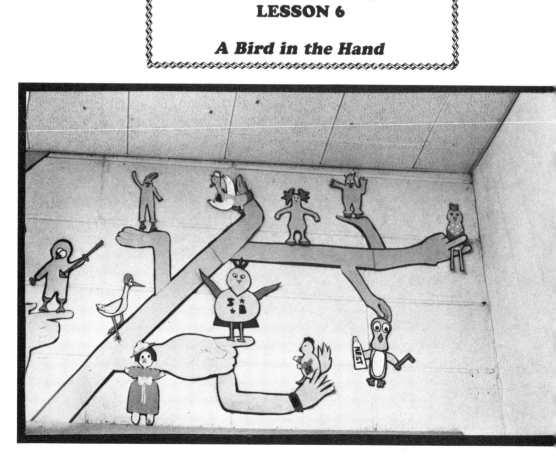

PREPARATION Cut 9" x 12" yellow and black construction paper in half to yield one of each for every student. Also prepare three-inch squares of white and orange paper and have practice drawing paper ready.

PRESENTATION Pass out the practice paper and start your students drawing cartoon-type birds. Illustrate some possibilities on a large sheet of paper at the front of the room using a wide felt marker. (You could predraw the lines lightly with pencil to bolster your confidence and amaze your class.) (See Figure 4-6a.)

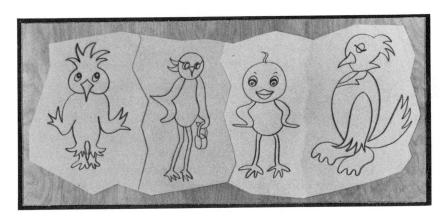

FIGURE 4-6a

Point out the ways in which cartooning is different from other drawing techniques. Characteristic animal forms are often changed to suggest those of humans. Features are either exaggerated or minimized to produce an amusing effect. No depth of field is indicated. Eyes are usually emphasized. All lines are black and uniformly wide throughout the drawing. Be sure to remove your demonstration drawings before students begin on theirs so there is no temptation just to copy.

Each child should make at least three practice attempts before deciding on the final form of his bird. Accessories and costumes should be indicated where they help to depict the personality of the bird and/ or what he is doing.

After deciding on the bird's final form, it should be rendered in cut paper. The general body shape should be made from the yellow first. Glue this to the black and cut out again leaving a black edging all around to produce the effect of the cartoon line. Facial features should be cut from appropriate colors. These are outlined in the same way with black paper before being glued to the head, to simulate more cartoon lines. All other additions should first receive the black outline treatment.

After all the birds are finished, collect them and put them away for a few days, then begin making the hands.

Cut 12" x 18" pink paper in half lengthwise and give one 6" x 18" piece to each student. Explain that now the subject will be "hands." Each hand is to be positioned in such a way that it will appear to be holding a bird. (Review some possibilities here other than the index finger perch position.) An arm should be attached to the hand and all will be rendered in cartoon-type lines as were the birds. The students may find it helpful to use their own hands as models. If fingernails show, they can be cut from manila paper and glued in place. The hands and arms should then be outlined with black paper.

DISPLAY Take a look at the assortment of arms and hands and organize them temporarily (on a large table or on the floor) in a kind of branching, tree-like formation. When you've got a good balance to the arrangement, transfer it to a soffit, sticking each piece in place with masking tape. Make a cartoon-like sign for the title and place it in one of the hands, then arrange the birds. Place them wherever they show off best in relation to the space and hand positions available. Work from the center of the display outward, alternating sides as you progress in order to maintain the compositional balance. Let your sense of humor guide you too.

Variations

I

Omit the hands and put up a sun which appears cold on the left and warm on the right. Show the birds at some stage of traveling south for the winter. (See Figure 4-6b.)

II

Very young children could manage a more simplified version of the cartoon bird by using a white circle for the head and birdseed for facial features. Attach real feathers to represent wings. (See Figure 4-6c.)

Hang the birds by a thread from the ceiling just a few inches in front of a sea full of whales. (See Figure 4-6d.)

III

Make the birds from sheets of 12" x 18" construction paper so that the finished products are enormous. Display them on a wide soffit, and include your wall clock if possible, as in Figure 4-6e.

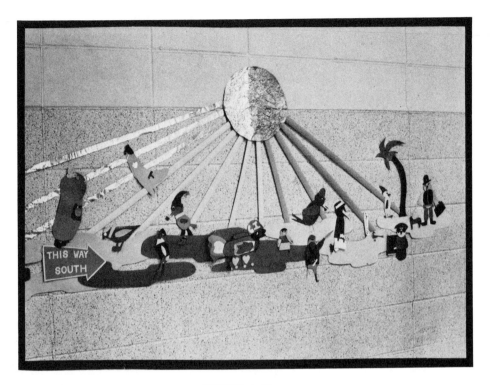

FIGURE 4-6b

FIGURE 4-6c

FIGURE 4-6d

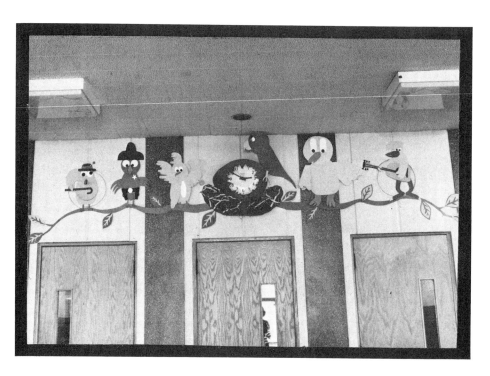

FIGURE 4-6e

This project uses carpet scraps (preferably the rubber-backed, easy-cutting variety), and they must be of a color which connotes coldness (blue, white, or beige) for theme continuity.

PREPARATION Cut the carpet scraps into enough portions so that each child may have at least one. The pieces do not have to be equal; variety of size will stimulate student imagination. Get out your collection of plastic packing pieces and yarn scraps (cool colors). Also prepare a quarter sheet of black construction paper for each.

PRESENTATION Explore with your class some of the folklore and tales about the yeti, big foot, and the abominable snowman. Since legitimate pictorial evidence is rather meager on the subject, your students will be unlimited in making their own. Invite them to choose from the array of materials you've set out to create some funny abominable snowmen. (Plus abominable snow *women*, of course.)

This is a project to have fun with. It is a great one to do on a hot day in May or September, and it is almost entirely student-directed once ideas start flowing. Since some of the monsters might be half hidden by icebergs or snow hills, just heads and shoulders could be considered a finished product for the slower-working students. Early finishers may enjoy the incongruity of making tiny flowers to be held in a monster's paw. When finished, put everything aside to dry undisturbed for at least six hours, because the plastic and yarn will not be satisfactorily stuck to the carpeting until the glue has hardened.

DISPLAY This display is a contrasting companion piece to *Straw Hut Village* (Chapter 2, lesson 6). If you have two bulletin boards of the same size, or a long wall space you wish to decorate, you may want to put up both at the same time. Background directions for the snowmen are the same as for the tropical scene with the exception of the paper color; just substitute blue for yellow and brown. Stretch a length of blue cellophane across the lower half of the oval, and on this tape up a series of pointed icebergs which you've cut from plastic sheet-form packing material. Arrange the snowmen wherever they look best. The display title and your grade and room numbers can be put on an extra iceberg, backed with blue paper, and taped to the wall separately.

Variation

Keep the title the same, but make "snow" snowmen from white paper and crushed plastic packing pieces and put them in action poses. (See Figure 4-7a.)

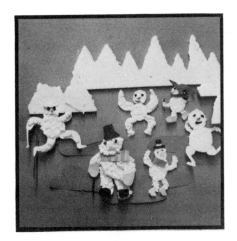

FIGURE 4-7a

CHAPTER

5

UTILITY SHAPES
AS ART DISPLAY UNITS

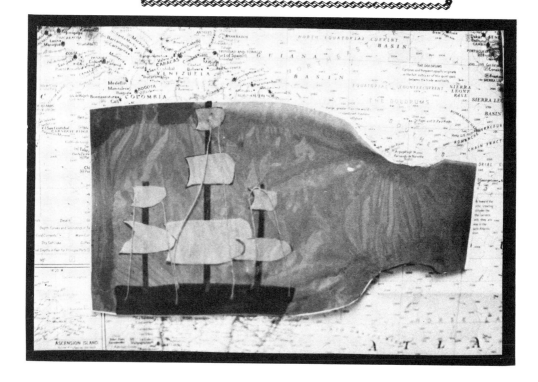

PREPARATION Find some pictures of tall sailing ships. (The ones having at least three masts are the most interesting.) Then requisition your school's opaque projector for the day on which you plan to present this project.

Other preparations would include cutting green cellophane into 6" x 9" pieces (one for each child) and, also, the same sizes and amounts of light green construction paper.

Practice cutting a bottle shape from the green construction paper. (Fold it in half lengthwise first for easy symmetry.) After you've manufactured a pleasing bottle shape, trace around it on the cellophane with a crayon and then cut out the matching "glass" bottle form.

PRESENTATION Show your students the ship pictures and invite them to verbalize their observations of the overall construction of the vessels. (If you do not have access to an opaque projector, let each child find illustrations of ships in his desk dictionary.) Point out the tapering of the masts, the placement and size of the yards and beams, and the function of the ropes. The scope of this discussion will of course depend upon the needs and interests of your class. (It might be tied in with a social studies unit).

When the ships' images seem to have been absorbed by the students, remove the pictures and ask each child to make a rough draft pencil drawing from memory. As the drawings are being reviewed, explain that over the years, craftsmen have constructed miniature replicas of ships, and some have done it in a most difficult way— working inside a glass bottle with special tools. Show the class your pre-cut cellophane bottle and the green paper shape it matches. Explain that they will be building ships in bottles too, but it will be done in an easier way.

After the light green paper has been distributed, demonstrate the drawing and cutting of the bottle shape. Unfold the bottle and flatten it. Let children choose brown or black paper for the hull, masts, and beams. When these are cut into satisfactory shapes and sizes, they can be glued in place on the green paper bottle. (A little crayon wood-graining creates an interesting effect on the hull.) (See Figure 5-1a.)

The sails can then be carefully measured and cut from white paper. When these are fastened in place, pass out white string (thin) or thread (thick) and remind the students that these "ropes" hold the sails in place and must be attached to them in such a way as to simulate that function.

Some children will want to accessorize the ships, and they should be encouraged to do so as long as everything is kept in scale.

FIGURE 5-1a

Finally, glue the paper bottle to the green cellophane. (You'll have to use rubber cement here because cellophane will not stay put with regular glue). When the glue is set, just trim away the excess cellophane.

DISPLAY Borrow a world map from the social studies department. It will have to be at least 4' x 3' and reveal a large blue expanse of ocean area. If you can't find a map, then make a special class project of enlarging a world map from an atlas on a large piece of white butcher paper and painting it with watercolors.

Attach the map to a wall with plenty of masking tape circles. Arrange a piece of rope on the wall around the map (also secured with tape circles, but make them very tiny so that they are inconspicuous). Accent the rope with the random placement of three or five black paper anchors. The children can tape their bottles to the map wherever they choose. Or, if yours is an exceptionally large class, you may want to make that final arrangement yourself so that each one is displayed to its best advantage.

Variation

Diversify the bottle shapes and decorate them. Use white and black chalk on grey paper to create magical genies that are seen as they emerge from the bottles. (See Figure 5-1b.)

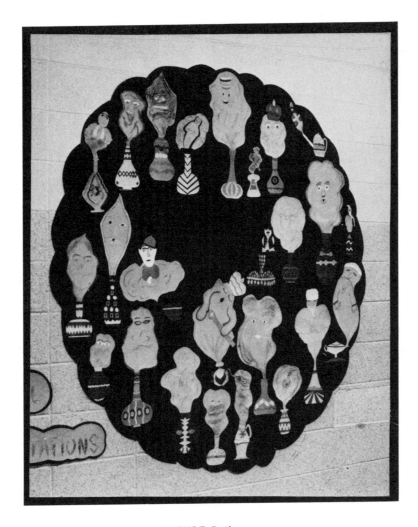

FIGURE 5-1b

If you happen to be working on a science unit which involves the study of insects, this lesson could be nicely tied in with it and used to display science drawings in a unique way. Or it could be presented simply as a drawing and construction lesson.

PREPARATION Cut some eighteen-inch long black construction paper into inch-wide strips. You will need one of these for each student. Also cut the same number of 6" x 4½" black paper rectangles. In addition to this, some heavy gage clear cellophane (or plastic sheets) will be needed to simulate lenses of magnifying glasses: six square inches per student. Gather together several compasses, 9" x 12" white drawing paper, and fine-tip markers (or drawing pens and ink) and you're ready to begin.

PRESENTATION Distribute the drawing paper and compasses to the students and tell each to construct a circle on the paper. The compass setting should be not less than 1½ inches nor more than 2½ inches. Explain that the circle represents the field of a magnifying glass and within it is to be made a greatly enlarged drawing of an insect. If you have decided to use this project in conjunction with a science unit, a review of the parts of insects may be helpful here. If the drawings are not meant to be representational, then any kind of creative fancy may be explored. After several trial drawings have been made, help each student to select one to render in pencil inside the prepared circle. When the basic parts have been fitted into the allotted space, the lines should be retraced with black marker and fine details added.

Following completion of the drawings, construction of the magnifying glass may begin. Pass out the 1" x 18" strips of black paper and explain how the strip is to be fashioned into a circle the same size as the compass-drawn circle. The strip will overlap itself by several inches and should be adjusted until it matches the drawing exactly. Fasten with glue. Cut out the white circle drawing and apply glue to its circumference. Place it flat on the desk and drop the strip circle on top so that its edges are immersed in the glue. Pass out the cellophane and draw a circle on it (with black marker; pencil won't show) the same size as the original compass circle. The negative circle from which the drawing was cut provides a convenient pattern. Cut out the cellophane circle and secure to the black circular strip with pieces of clear tape. (Have the students work in pairs here, since this is a four-handed operation.) Distribute the remaining rectangles of black paper. These are to be fashioned into handles by rolling the paper around a pencil to make a thin cylinder. Attach this to the lens with more tape.

DISPLAY Back a small bulletin board with grey paper and arrange on this some elongated triangles of yellow. The magnifying glasses can then be pinned to the background in a random placement. Use two straight pins for each, pushing one through the handle and the other through the black rim and well into the bulletin board.

To display on a wall, the magnifying glasses would first have to be glued to the yellow triangles at the contact points, and then the triangles can be stuck to the wall with circles of masking tape.

Variations

I

Simulate the idea of a lens in a different way: Draw a circle and around it two increasingly wider half-inch rims. Paint a picture within the space, then separate by cutting the inner circle from the outer rims.

FIGURE 5-2a

Elevate each rim successively further from the center so that the picture acquires an anamorphostic effect. (See Figure 5-2a.)

II

Use horseshoe shapes as frames for pictures that show situations involving good luck. (See Figure 5-2b.)

FIGURE 5-2b

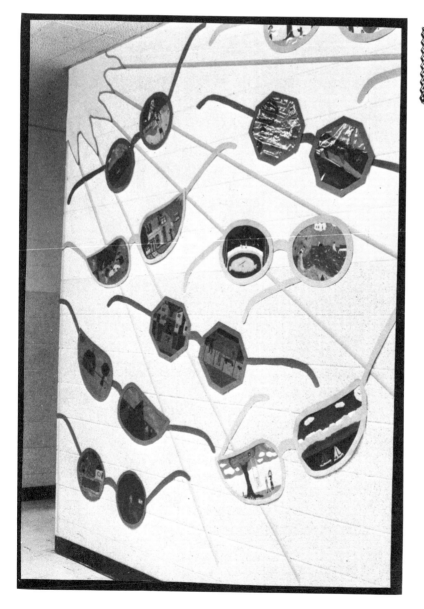

PREPARATION You will need to prepare patterns in advance of this lesson. Also, dividing your students into pairs will be necessary so that you are assured of ending up with symmetrical sunglasses. Use 12" x 18" construction paper and cut from each sheet one shape (see Figures 5-3a, 5-3b, and 5-3c).

FIGURE 5-3a

FIGURE 5-3b

FIGURE 5-3c

Print the words RIGHT HALF on one side of each pattern and LEFT HALF on their backs. Set out your tempera paints and you're ready to begin the first part of the project.

PRESENTATION Explain to the class that they will be making paintings of any sunny summer scene, and each picture will eventually be one half of a pair of sunglasses. Let the students pair themselves off and then each couple should choose one of the sunglass-frame shapes—one member drawing the right half and the other the left half on his painting paper. (Better do some checking here to be sure they've all done it correctly.) Sketches for the paintings can be made and the tempera applied.

When the paintings are dry, let each couple choose two 12" x 18" sheets of matching colors of cellophane. Then have each student draw a one-inch margin around the edge of his picture. Spread rubber cement in the margin and place the cellophane on top of the picture, pressing down evenly on the cemented areas. Leave this to dry.

Now let each couple select two 12" x 18" sheets of matching colors of construction paper and go back to the patterns, drawing as before one RIGHT and one LEFT. When the pattern is removed from the paper, a one-inch margin should be drawn around each shape (see Figure 5-3d).

FIGURE 5-3d

This time the *inside* should be cut out plus the outside of the margin, leaving the frames. The frames should then be rubber cemented to the cellophane-covered pictures and, when dry, excess cellophane trimmed away. Braces to connect the two eye pieces can be cut from the scraps left over from the frames; however you will need to provide an additional full-sized sheet of that paper to make the stems. Since this gets to be a rather cumbersome item at this point, it might be best to

leave the stems separate until you are ready to put up the display. It makes that job easier and gives you a freer hand with the arrangement.

DISPLAY Piece together a large quarter circle of yellow construction paper, then edge it with orange crayon. Put it up on a wall with one edge touching the ceiling, then run strips of colored tape or paper diagonally down the wall to symbolize a radiant sun. Apply circles of tape to the backs of the sunglasses and fasten them to the wall beginning just under the sun and working your way down to floor level. Positions of the sunglass stems should be varied to add interest to the arrangement.

Variation

Make the sunglasses the same size as real ones and fasten them to your class' self-portraits. This creates a rather different display for September which reminds students that even though school has started, Summer Isn't Over Yet. (See Figure 5-3e.)

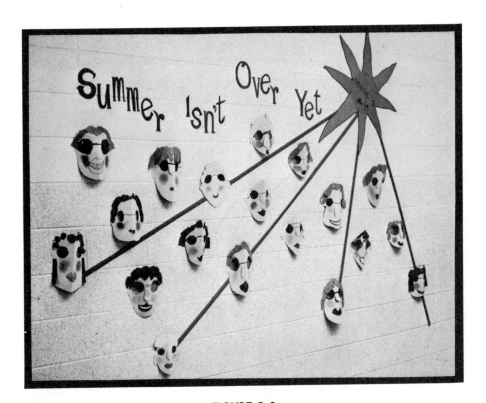

FIGURE 5-3e

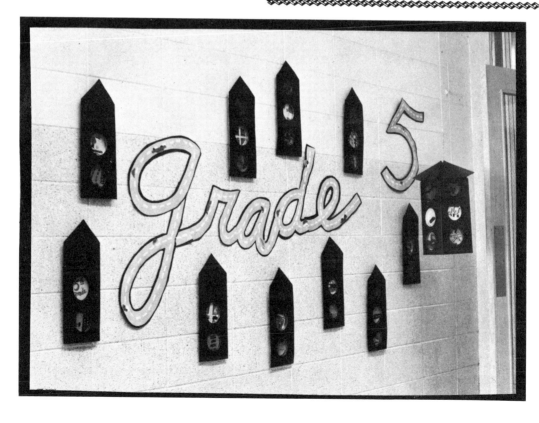

PREPARATION Jar lids and red, yellow, and green cellophane are the essential ingredients for these traffic lights. The lids should measure at least 3¼ inches in diameter and be one-half inch deep. You will need one for each student.

Make a model traffic light before you present the lesson so that the class may visualize the project more easily. Trim a 12" x 18" sheet of black construction paper down to 7" x 18", then cut a point at the top. Lay three of the jar lids down the center taking care to space them evenly. Draw around each lid, then cut a hole in the black paper slightly smaller in diameter than the lid outlines. With masking tape, fasten a six-inch square of cellophane on the back to cover each hole. Place the red at the top, yellow in the middle, and green at the bottom. Then secure the three lids with tape on top of the cellophane (see Figure 5-4a).

FIGURE 5-4a

PRESENTATION Put up your traffic light model and ask your students to imagine this to be a light at any street corner. Then ask what the traffic

light would see from the top of its pole. Draw the outline of one of the lids on a piece of white paper. Make a quick sketch inside the outline of one of the scenes suggested by the students and cut the circle out (again cut it slightly smaller than the drawn outline). Loosen a strip of tape on one of the lids on the model and slip the sketch inside it so it can be viewed through the cellophane from the front.

Distribute a lid and a piece of drawing paper to each child. He should draw a circle and then render his drawing inside it. The subjects should be varied and might reflect ideas from a traffic safety lesson. After drawings are complete they may be painted or colored with crayons. Then cut them out and glue inside the lids.

Following your original model, prepare enough black housings for the lights. Children could work in groups of three to do this, or let the ones who finish their paintings early construct enough for the whole class. Another job for the fast workers would be to make a large, twisting highway which spells out your grade number (as shown in the project photo). To make this, spread out ten sheets of grey construction paper in a row. Fasten them together temporarily with a little masking tape to prevent slipping, and write the word and number with the flat side of a three inch white crayon. This leaves a wide outline which can then be permanently connected at the continuity points. When this is all cut out and assembled, complete it with a dotted yellow center line and very small cars.

DISPLAY Choose a wide wall area and tape the "road" securely to it. Apply circles of tape to the lid backs on each traffic light and arrange them at random around the road. You *could* stop there and have a very effective display, but if you want it to be even more unusual, combine four of the units into one three-dimensional piece to hang from the ceiling.

To make the special hanging lantern, you will need a box with four six-inch wide sides (a saltine box, shoe-box, or two egg cartons taped together). Attach one unit to each side and secure a long string to the center of the box top, then fold the black construction paper points in until they meet (where the string emerges from the center). Suspend this from the ceiling so that it is far enough from the wall to permit it to turn freely.

Variation

Instead of pictures, print traffic safety rules on the white paper circles so that they may be read through the cellophane.

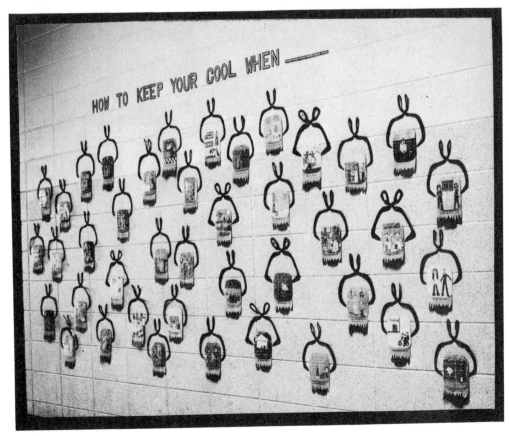

HOW TO KEEP YOUR COOL WHEN ———

PREPARATION These simulated blocks of ice use the same kind of plastic meat-packaging trays described at the beginning of lesson 6, Chapter 2. You will need one of them for each student plus a 6" x 9" piece of light blue construction paper and a 6" x 6" piece of dark blue paper. Make a pair of ice tongs from black construction paper. Cut two identical parts with the paper folded, as in Figure 5-5a, then reverse one piece, join below the handles, and spread the points wide enough apart to "hold" the plastic "ice block"(see Figure 5-5b).

FIGURE 5-5a

FIGURE 5-5b

The block should be backed with the light blue paper which has been cut smooth and flush at the top, but jagged and projecting at the bottom, as in Figure 5-5c.

Cut the dark blue paper into more jagged edges and attach it so that it shows below and beyond the light blue (see Figure 5-5d).

FIGURE 5-5c

FIGURE 5-5d

PRESENTATION Print the words HOW TO KEEP YOUR COOL WHEN . . . on the chalkboard. Tape your ice block and tongs just underneath the letters and explain to the class what is being represented here. The double meaning of the word "cool" will become apparent to the students when you tell them that the space inside the ice block will hold a picture of some situation in which a person might "lose his cool." Ask them to relate a few personal experiences where they felt embarrassed, fearful, or threatened. Choose one of these as an example and ask how the situation might be depicted with cut paper inside the ice block. What would be the essential parts of the picture necessary to convey the idea? Then, in as few words as possible, print a verbal description on the *light* blue icicles below the ice block. This description becomes a continuation of the phrase HOW TO KEEP YOUR COOL WHEN . . .

Next, start discussing solutions to the problem, or what action the person might take in order to avoid losing his cool. The solution should be entertaining and contain some element of surprise. Condense it into a short sentence and then print it on the *dark* blue icicle section.

Pass out practice drawing paper. Each student should set about formulating his own project idea in terms of: 1) a potential loss-of-cool situation (accompanied by a planned visual and verbal expression of same), and 2) an entertaining solution to the problem which should contain an element of peer group credibility. Have them use a sketch facsimile of the ice block with its light and dark blue icicles. A lot of talking among themselves will be necessary, so don't plan to present this project on a day when you want everything to be nice and quiet. However, the discussions will be creatively productive and this is, after all, what you want.

You will be checking each idea during the planning stage, of course. Then when all are ready to begin, pass out the plastic ice blocks and the light blue paper so that the outline may be traced and cut out for background. (Some subjects may require a color other than light blue, but stick to it wherever possible since it lends more unity to the overall idea of coolness.) Have a quantity of flesh-toned paper available, since each project will have one or more people in it—the remainder of the colored paper needed may be chosen individually from the scrapboxes. The work will require at least three art periods and during the last one, all words should be neatly printed with a fine-tip marker, ice block glued in place over the picture, and the black ice tongs cut out and assembled.

DISPLAY Cut out the letters for "HOW TO KEEP YOUR COOL WHEN..." using the method described at the beginning of Chapter 1, lesson 1. Tape this sentence fragment in a straight line across a wall at your eyelevel. Then simply tape up the ice tongs and their contained blocks at randomly spaced intervals underneath.

Variation

Situations illustrating good manners may be depicted in simple line drawings after a discussion on the subject. With this collection of pictures, A STUDENTS' CLASSROOM ETIQUETTE booklet or display can be created. (See Figure 5-5e.)

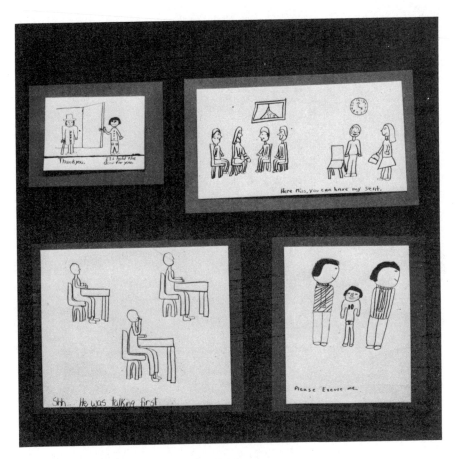

FIGURE 5-5e

LESSON 6

Double Frame Pictures

This project demands time and patience. However, motivation seems to be self-renewing if a good beginning is made.

PREPARATION The subject matter of the pictures must be decided upon first. If the lesson is to be worked as a unit in conjunction with a curriculum area, the pictures could be illustrations of a book, story, or poem in language arts. They might depict historical, cultural, or geographical scenes for social studies, illustrate health/safety codes, or represent some aspect of science. If the subjects need not be unified under a general theme, then each child could work individually to produce a pleasing picture which utilizes his own choice of subject matter and expresses something about him and his environment.

You will need one piece of 4" x 7" white drawing paper and three 6" x 9" pieces of black paper for each child. The remaining colored papers can be taken from the scrapboxes.

PRESENTATION Each child should plan his picture on the white drawing paper. It is to function as a "blueprint" from which he will construct the final work. This initial stage should be done in pencil and colored with crayon. Make the class aware of foreground, middleground, and background and the sizes of objects relative to each space: Foreground = large, background = small, and middleground = medium. Each piece of the *black* paper will carry the contents of one of the three grounds. These vehicles are prepared by centering, then tracing around the white drawing paper, as in Figure 5-6a.

FIGURE 5-6a

Care must be taken to position the drawing paper exactly the same way each time so all outlines are identical.

Cut on the pencil lines of the first two and leave the third intact. (See Figure 5-6b.)

FIGURE 5-6b

The first of these frames will hold the foreground, the second the middleground, and on the last "solid frame" will be arranged the background.

Begin with the background. Analyze the "blueprint drawing" and decide which parts are farthest back. Cut those parts from appropriate colors and glue them in place.

Next fashion the middleground parts, but caution the students not to do any gluing here until final decisions regarding placement have been made. (If this lesson is to occupy several periods—and it will—it would be helpful for the students to save these parts in separate envelopes so they will not be confused with foreground pieces.)

Foreground parts should be cut last and temporarily arranged in place without gluing. (See Figure 5-6c.)

Now pile everything together. When positions have been adjusted so that the parts interrelate nicely, the pieces can be fastened to the sides of the appropriate frames.

At this point you are ready to form the pictures into a three-dimensional structure. Pass out two strips of black paper to every student. Each strip should measure 1" x 10". Rulers will be needed for this operation so that students can divide the strips into eight segments of 2½ inches each. When the segments are cut, they are to be folded at

one-half inch intervals to make little "oblong boxes" when fastened with glue. (See Figure 5-6d.)

FIGURE 5-6c

FIGURE 5-6d

Demonstrate this process for the class by making an oversized folded example. They can follow you one step at a time. If your class is composed of very young children, you might need to enlist the help of some student aides for this part, since it is essential that all these "boxes" should be of uniform height. If they are not alike, the final product will be lopsided and disappointment will result.

Four of the "boxes" should be glued to the background piece, as in Figure 5-6e.

FIGURE 5-6e	FIGURE 5-6f

The remaining four are positioned and fastened to the middle frame in the same way (see Figure 5-6f).

Finally all the frames are combined by stacking and gluing one on top of the other, taking care in the process to obtain uniformity of alignment. (See Figure 5-6g.)

FIGURE 5-6g

DISPLAY These pictures can be fastened to a wall with circles of masking tape or pinned to a bulletin board.

Random or regular arrangements are equally pleasing, and of course either should be placed at a child's eyelevel. If you want a more colorful, overall effect, overlap rectangles of colored paper between the pictures.

Variations

I

Make the frames square rather than rectangular and fasten a piece of clear plastic plus crossbars on the top one. This creates the illusion of a window, and the observer would be inside looking at an outdoor scene. (See Figures 5-6h, 5-6i, and 5-6j.)

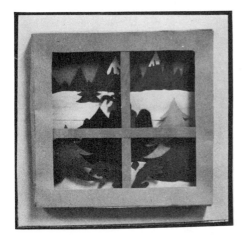

FIGURE 5-6h

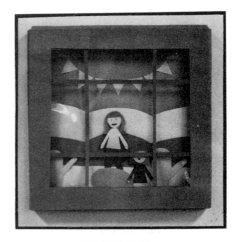

FIGURE 5-6i

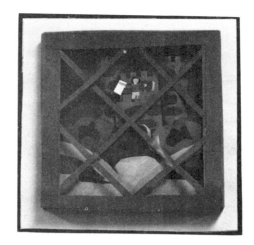

FIGURE 5-6j

II

Work with circular frames and suspend a flower in each. Hang mobile fashion so that all sides will be viewed while turning. (See Figure 5-6k.)

FIGURE 5-6k

PREPARATION Make a pattern for a giant-size light bulb by folding a piece of 9" x 12" construction paper lengthwise and cutting the shape as shown in Figure 5-7a.

FIGURE 5-7a

Get some clear cellophane or sheets of thin, stiff plastic (one 9" x 12" piece for each student). Any similar material will work if it is transparent and conveys the idea of light-bulb glass. Check your silver foil supply (gum, candy wrappers, etc.) and see if you have enough 3" x 4" pieces to supply your students with one each.

Make up a model of a large light bulb to show your class during presentation. To do it, draw around your pattern on a piece of colored construction paper (sky blue would be a good color), then cut it out. Draw around the bottom part of the bulb on silver foil paper to simulate the metal threaded portion. Then trace the top rounded part on the plastic material for the bulb's glass dome. The silver should overlap the glass a little. Decide upon a theme for the picture you are about to make on the blue paper. This will be seen through the "glass" and should depict, in cut paper, any *great idea* in the history of man which was instrumental in bringing about significant cultural changes—perhaps a windmill. That is a simple enough subject which you can execute in about ten minutes. Cut the mill and sails of black paper and glue them toward the top of the blue paper bulb shape. Then add a few hills below it in several shades of green. (See Figure 5-7b.)

FIGURE 5-7b

Use clear tape to hold the plastic "glass" covering in place over the picture, then glue the foil to the base.

PRESENTATION At the bottom of your chalkboard, draw the eyes, forehead, and hair of a four-foot wide head. Ask someone in the class to suggest a way in which this giant person could be shown to have an *idea*. The response is certain to be "a light bulb drawn above the head."

Quickly sketch in several light bulbs at random on the board—same size as your prepared example—then explain to the class that the head represents the collective *mind of man* and the light bulbs are going to show some of the great ideas which time has elicited.

Focus here upon a discussion of great ideas. Work from the general to the particular, or reduce from the complex to simplistic components. Harnessing natural resources might narrow down to harnessing wind power to sailboats, gliders, and windmills, and at this point you put up your prepared example. The students should understand that each of them will be depicting a great idea visually through the medium of cut paper, and that the overall dimensions of the picture will conform to the shape of a light bulb.

Check each child's project plan individually at its beginning to avoid duplication and to assure sufficient narrowing of the subject which should be commensurate with the particular child's ability. When

confidence has reached the necessary motivational level, each student should choose colored construction paper from which to draw and cut the light bulb shape (offer the pattern, but its use should be optional). The colored background would of course be chosen with the theme of the picture in mind, and the composition could be planned with the bulb shape in either a vertical or horizontal position.

Students who finish early can begin to construct the giant head needed for the display. To begin this, lay out four 12" x 18" sheets of pink or flesh-tone paper to form a large rectangle. Glue these together and round off the top, as in Figure 5-7c.

FIGURE 5-7c

Cut five curving "hair" sections from 12" x 18" brown paper and overlap them around the top of the head. Cut the eye whites from two stacked sheets of 9" x 12" paper and fill them with colored circular irises. Add black fringed lashes if time permits and glue eyebrows in place above them.

DISPLAY Choose a wall space at least nine feet high and ten feet wide for this display. The large head should be positioned down at floor level with the light bulbs placed at random above it all the way to the ceiling. Cut some squiggly line strips from yellow paper and use them to connect the bulbs to the head. Other yellow paper lines may be used to surround some of the bulbs and represent the "glowing" feature.

Cut out some large letters to tape across the display's center which will identify it as "GREAT IDEAS."

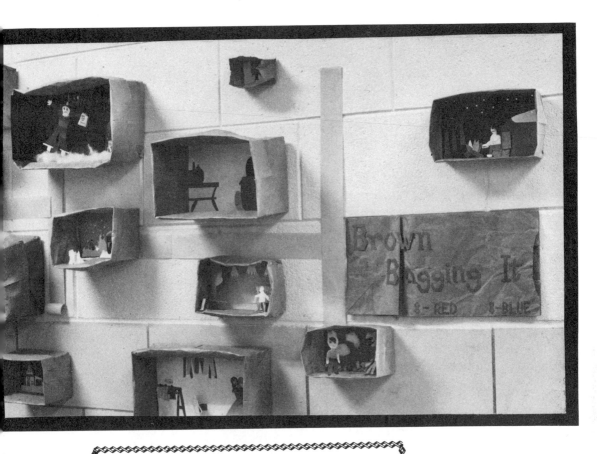

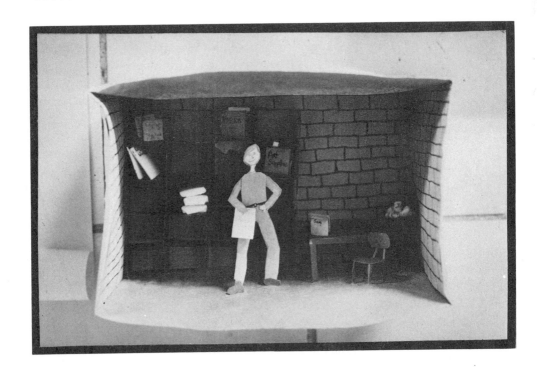

PREPARATION Cut a large brown grocery bag in half crosswise. Open it up and fold the edge down evenly all the way around so that it finally stands about six inches high. Very carefully dismantle another bag in such a way that you can see exactly how the paper was shaped, folded, and put together. Using this as a model, make a very tiny brown bag of your own from the paper you cut off the first bag. The finished miniature should be about two inches high and 1" x ½" at the base. This is now the beginning of a unique and very inexpensive diorama project absurdly unified by the theme of brown paper bags.

PRESENTATION Tape the large bag, which you prepared, to the chalkboard at the front of the room so that the opening faces the students. Tell them that inside this space will be constructed a scene showing some situation in which a paper bag plays a key role. Place your miniature bag inside the large one and explain that if this size bag is used in the diorama, everything else would have to be made in proportion to it. Help students think of all possible uses for paper bags and then imagine these happening in very unlikely places (e.g., a brown bag lunch on the moon). Of course some very common situations will make interesting subjects too and should not be eliminated as possibilities.

Each student should bring to school the size bag which best suits the theme he has decided upon. Some of them will not remember, so you'll need to bring in some extras. And you'd better mention that the smaller the bag, the tinier will have to be the picture pieces which will go into it.

Direct the students to cut down and fold back their bags just as you did. Then give them some help in constructing the miniature bag from the scraps. From this point on, each student may be left to develop his idea as he chooses. Fabric and scrap-paper boxes should be made available plus any other interesting material (wood scraps, stones, twigs, carpet scraps, buttons, etc.). A background of colored construction paper or wallpaper cut to fit the back (which is actually the bottom of the bag) will set off the foreground material more effectively. Figures can be made to stand vertically by attaching small bent tabs of paper to the bottom and sewing threads inconspicuously from the top.

DISPLAY These projects are more easily displayed on a large bulletin board. They can be fastened in position simply by pushing two straight pins right through their backs and slanted down into the board fiber. However, if you wish to use wall space for display, attach at least eight circles of masking tape to the back of each bag and press firmly in

place. Arrange the bags at random, then place strips of colored paper in between to direct attention. Cut letters for the display title from dark brown construction paper, then glue them to (what else?) a flattened brown bag.

CHAPTER

6

SHOWY
HALL
DISPLAYS

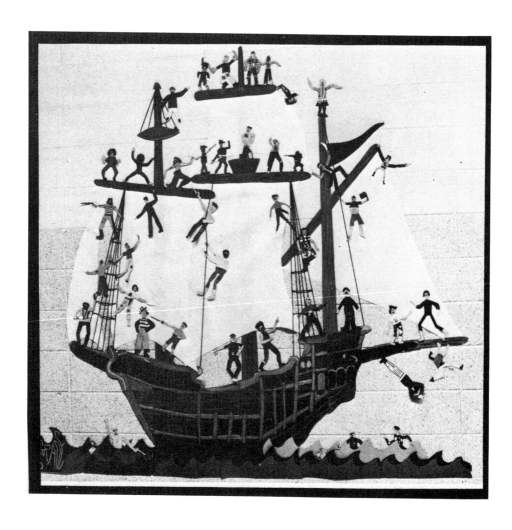

216

This pirate ship stands twice as tall as the students who made it. It is quite a spectacle and appropriate for any time of the year.

PREPARATION Review the people-drawing technique explained in Chapter 2, lesson 5. In addition to those materials listed, you might make available anything in your miscellaneous scrap collection which would aid in transforming these figures into pirates. Essentials would be: foil-paper (knives and buckles), vinyl or leather scraps (boots), yarn (beards and hair), thin wood (peg leg), red fabric (scarves). As the pirates take shape and are being appropriately costumed, some students may wish to work together to coordinate the action of their figures; they will probably think of that themselves. Also, do *not* put out the red paint for this work period, or they'll get carried away and you'll end up with more *wounded* pirates than you bargained for! Explain that all of these will be displayed at some place on a huge ship, so students can plan arm and leg positions with decks, ropes, and sails in mind.

While students are finishing their pirates, you can prepare for the presentation of the ship project. On a piece of light brown construction paper 6" x 18", copy this sketch (see Figure 6-1a).

FIGURE 6-1a

Choose brown and gold crayon colors and apply these heavily to simulate polished wood. Using a ruler, mark off the paper so that it is divided into eight 3" x 4½" rectangles. Cut these pieces apart but keep them assembled so that the picture of the ship's hull can be recognized by the children (see Figure 6-1b).

This now becomes a working scale model. The sections should be distributed one at a time in sequence. Two children can work on one section. First they should make an enlarged sketch of the section on a piece of 12" x 18" light brown construction paper. The sketch proportions

should be exactly like those on the model but in larger scale. As they draw, the students should be comparing their sections with those that are adjacent so that in the end, when the entire ship is assembled, one section will join the next perfectly. Crayon coloring patterns will also have to duplicate those on the model and comparisons of crayons used must be made and duplicated as one section joins another.

FIGURE 6-1b

Students who are not working on the hull should use the same wood-tone crayon colors and make masts and spars. Three mast sections can be drawn on one piece of 12" x 18" paper. These should be tapered so that they will fit together end to end to form one tall mast when assembled. A second mast tip, which shows above one of the sails, plus four spars, can be made on another piece of 12" x 18" light brown paper. Anyone who doesn't have a job can cut black yarn into twelve 30 inch lengths for ropes and ladders, fashion a pirate flag, and cut some wavy ocean water from blue paper.

After all the crayon work is finished (and this must be heavy and waxy), the sections should be cut out and arranged, according to the scale model, in sequence on the floor. Any final fitting adjustments can be made at this time. Also three one-yard lengths of white roll paper can be cut and saved for fashioning sails later.

DISPLAY Apply masking tape to the backs of all the pieces and begin to assemble the boat on the wall beginning about one foot above the floor. After the hull is in place, put up the mast on the left side (see lead photo) and fashion a curved triangular sail from one of the white roll-paper lengths. Put all the spars in place and then form and attach the remaining sails. Ropes and rope ladders go on last, and these are more easily attached with double stick transparent tape.

Put up the pirates all over the ship. Keep a good balance as you do it and avoid allowing any area to become too crowded. If you run out of ship space, float some of them in the waves below.

Variations

I

Working on a smaller scale, make *three* ships and have them ready for a Columbus Day display.

II

Change the ship's design slightly and populate with pilgrims instead of pirates. This becomes a Mayflower replica.

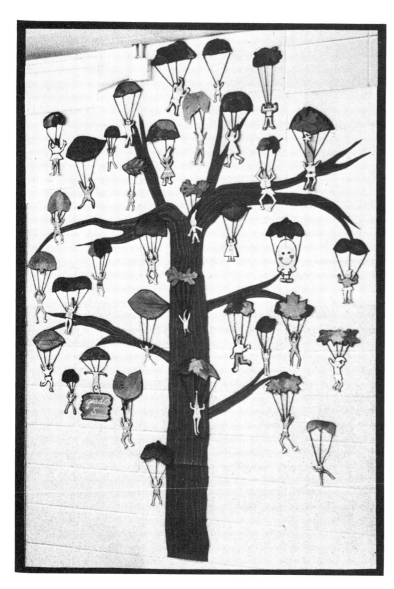

LESSON 2

Parachuting Elves

This project is a fanciful explanation of why leaves fall, and in spite of the level of fantasy involved, it appeals to older children as well as to the very young.

PREPARATION Make a large varied collection of fall leaves, then press them in books (catalogs or discarded city telephone directories are ideal for this) for two weeks. The leaves eventually are to be fashioned into parachutes for elves, and while they are drying, you can be preparing the giant tree which will function as an overall background of the display.

You will need six 12" x 18" sheets of light brown construction paper. Lay out three of them and, using a yellow crayon, draw several ovals spaced at random on each piece of paper, as in Figure 6-2a.

Make parallel wood-graining lines around the ovals—be sure to press down hard on the crayon as you work (see Figure 6-2b).

These are sections of the tree trunk. On the remaining three pieces of paper make some tapering branches and give them the same wood-graining treatment.

Mix a quarter of a cup of brown tempera paint with an equal quantity of water. Brush it directly over the crayon work on all units of brown paper. The paint will roll off the waxy crayon lines but will be absorbed by the paper, thus heightening the wood-grain look. Allow all this to dry, then stack the sheets and store them flat until the time comes to put up the display.

FIGURE 6-2a

FIGURE 6-2b

PRESENTATION Remove several of your prettiest pressed leaves from their storage place and display them for your class. Ask the children to imagine that the tree, on which the leaves grew, was inhabited by tiny elves. When time came for the leaves to fall, the elves used them as parachutes and had a lot of fun floating to the ground. Show how various combinations of leaf shapes can be made to resemble that of a parachute, then add some strings beneath it, gathering them together at the bottom where the elf would be attached.

Lay out all of your pressed leaves on a table and invite the children to choose several and create parachute shapes of their own. Pass out 9" x 12" black paper so that the final arrangements may be glued down and set aside to dry. After about fifteen minutes, the excess paper may be trimmed away, and in the process a narrow edging of black should be left around the entire parachute shape.

Now begin to make the elves. Orange, yellow, and red paper would be appropriate for their suits since those are the colors found in the leaves. Faces and hands can be any color you want them to be, and silver or gold foil paper scraps inspire the making of a variety of accessories. Each elf's size should be in proportion to that of the parachute he will be using. Arm and leg positions should help convey the impression of floating through air. Assemble all the elf parts on the remaining black paper and cut out, leaving a black edge as on the parachute. Connect elves to parachutes with black strings taped to the backs.

DISPLAY Find the three tree trunk sections you prepared earlier and tape them to the wall end to end vertically. Trim the edges of the highest one slightly so that the trunk appears to be narrower at the top. Swing two large branches out from the top of the trunk horizontally, then add all remaining branches alternately on the trunk's middle.

Apply tape to the parachutes' backs and press gently to the wall to avoid cracking the leaves. A random arrangement works best. If you run out of air space, place some near the ground.

Variations

I

Use some of the leaves as feathers for unusual turkeys. The remaining leaves can be used to foliate small background tree trunks which are scaled-down versions of the giant parachute tree. (See Figure 6-2c.)

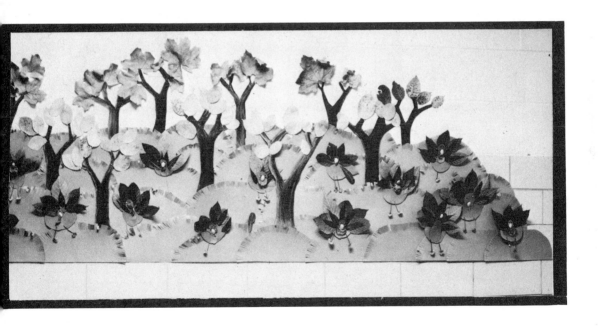

FIGURE 6-2c

II

Combine the elves with giant silver-foil daisies for a fresh spring display. (See Figure 6-2d.)

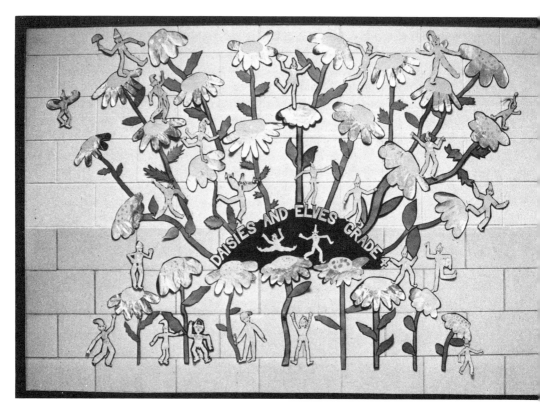

FIGURE 6-2d

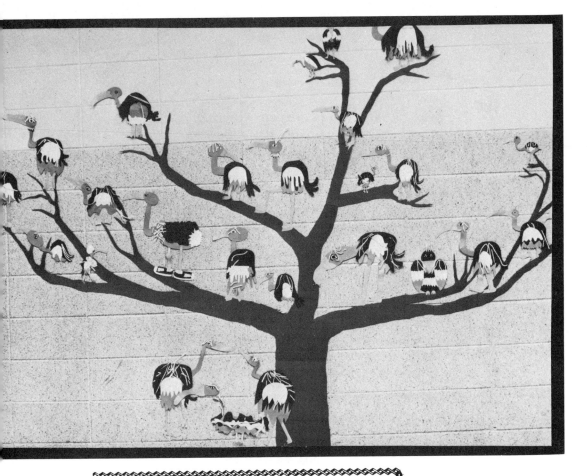

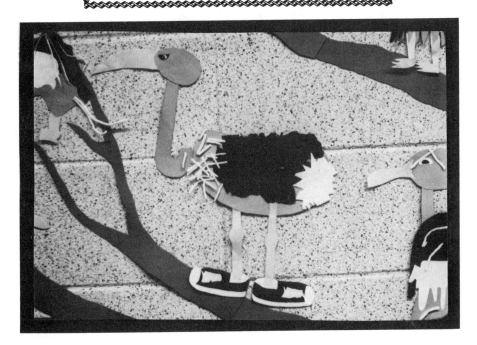

Even though vultures are carrion birds and somewhat repulsive as a species, calling them by another name changes the frame of reference and emphasizes their comical qualities. They have subject appeal with a wide range of interpretation.

PREPARATION Make up a huge model of a buzzard: cut an egg shape from 9" x 12" grey paper and attach to that a curving grey neck and head, as in Figure 6-3a.

Add to this wings, tail, and neck feathers cut from black and white paper. (See Figure 6-3b.)

Finish up with legs, feet, and beak made from orange-yellow plus a black and white eye. White stringy plastic packing material contributes a nice scraggly texture, but use it sparingly or the effect will be lost. (See Figure 6-3c.)

The finished bird will be about eighteen inches high.

FIGURE 6-3a

FIGURE 6-3b

FIGURE 6-3c

PRESENTATION Show your example to the class and explain that this is meant to be a funny interpretation of a vulture. Each student will be making one bird so eventually there will be a whole flock of buzzards to roost in a giant tree (leftover from the last project).

Pass out the paper: each child should have two 9" x 12" grey, one white, one black, one orange-yellow, and seven or eight pieces of the white plastic stringy stuff. Point out the basic shapes and features used in the example and then take it down. Each student should make his own interpretation of a buzzard, not just a copy of yours; they should be fanciful and above all, funny.

DISPLAY Save the tree parts from the parachuting elves display in the preceding lesson. Omit the first two trunk sections so that the buzzard tree will appear lower to the ground. Arrange the branches so that they spread horizontally and provide roosting places for the birds.

Variations

I

Don't throw away that tree! Use it at Christmas time to display giant pears, each of which is decorated with a "partridge." This, of course, gives you a PARTRIDGE-*ON*-A-PEAR TREE. (See Figure 6-3d.)

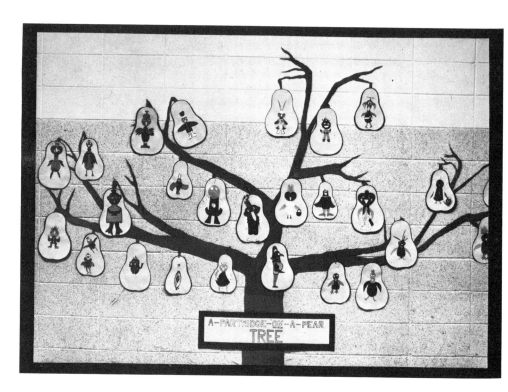

FIGURE 6-3d

FIGURE 6-3e

228

II

Construct the birds on a smaller scale and make them more graceful in appearance. Put them together for a decorative wall of Ibises. (See Figures 6-3e and 6-3f.)

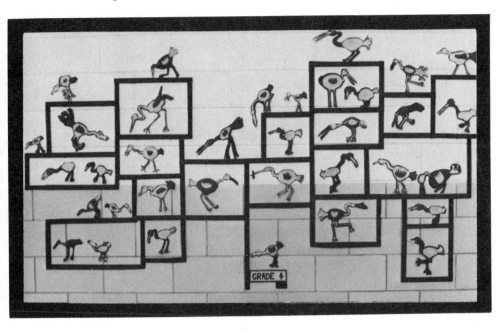

FIGURE 6-3f

Young children have difficulty understanding the diversity of human values. Immersed as they are in our heavily hedonistic and materialistic culture, children are usually at a loss to know how to structure a consistent, compatible, and functioning value system for themselves. With this lesson you can, to a small degree, help them discover some personal truths.

PREPARATION Buy a roll of very shiny gold foil wrapping paper and cut it into enough 6" x 6" squares for your class. Request a pack of 3" x 5" unlined file cards from the supply room and gather together some kind of watercoloring medium such as fine-tip markers or pan watercolors. Using these materials, make a model of a large and unusual gold nugget.

First stack one index card on top of another and cut both at once into an irregular shape. Hinge these together at the top with a small folded tab salvaged from the card remnants so that it makes a lift-up unit. Crinkle one of the gold foil sheets to make it slightly three-dimensional, then fold the edges under all around so that the finished shape conforms to that of the cardboard lift-up unit. Glue the foil right on top of the shape (see Figures 6-4a and 6-4b).

When the glue is dry, open the unit and draw a simple picture on the inside. Outline the drawing with black pen or markers, then add watercolor.

FIGURE 6-4a

FIGURE 6-4b

PRESENTATION Since gold is universally considered to be among the highest of materialistic values, this subject could be an appropriate beginning for your class discussion. Ask what other values would be considered "materialistic," and as these are mentioned be sure to stress the category: materialism. Then ask what kind of human values seem to be *higher* than materialistic ones. After suggestions such as friendship, religion, education, and morality are made, point out that all of these have something to do with the mind and are certainly more important and more worth developing and living for than materialistic values.

Now the trick is to help each child find a way to represent these higher intangible values pictorially. Tape your gold-nugget model in its closed position to the chalkboard; around it draw some similar shapes to represent more giant nuggets. Explain to the class that the intent of this part of the display is to convey the idea of a gold mine (material-ism), but represented in the second aspect (lift up to reveal the picture) are the higher values that go *beyond* materialism and are indeed BETTER THAN GOLD. At this point, print that phrase under your sketch and then begin to help the students get started on their concepts. Practice sketches should be made first, and when all these are finished, explain how to make the nuggets.

DISPLAY Tape four sheets of 12" x 18" black construction paper to the wall at your eyelevel to form a large rectangle. Cut six pieces of 12" x

18" yellow paper into five-inch wide curves, then make a series of obtuse points along the inner and outer edges of the curves. Trace around the outside edges with black marker, then put up the curved pieces so that they surround the black rectangle and conceal all of its corners. The resulting effect will be something like a large hole in your wall, but it represents the dark inside of a mine. Make a small replica of an ore cart and place it on brown rails in the center of the mine. The rails should rest upon a series of yellow ties which diminish in width as they move away in space. Position the nuggets so that they surround the cart.

Cut the letters for the title from two-inch rectangles of gold paper (see Chapter 1, lesson 1), then back-edge them with black paper. Glue or tape these to the yellow curved margin across the bottom of the display.

Variations

I

Exploring the same philosophy as for the gold mine, use treasure chests with hinged, functioning lids as the containers for the pictures. (See Figure 6-4c.)

II

An emerald mine would be similar in construction to the gold mine. Students enjoy creating bearded gnomes to dig out the gems. (See Figures 6-4d and 6-4e.)

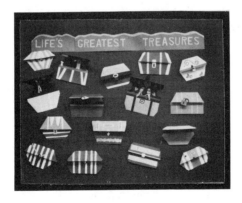

FIGURE 6-4c

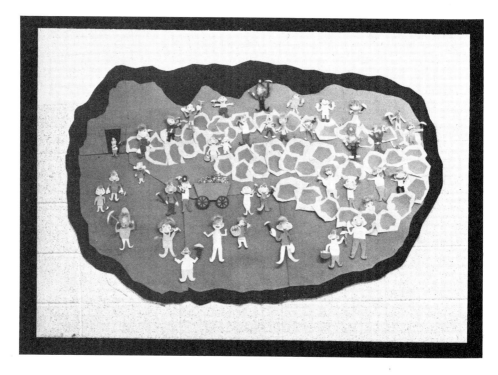

FIGURE 6-4d

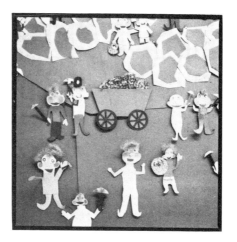

FIGURE 6-4e

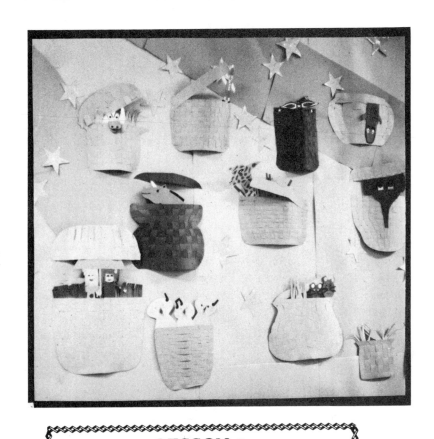

LESSON 5

Basket Surprises

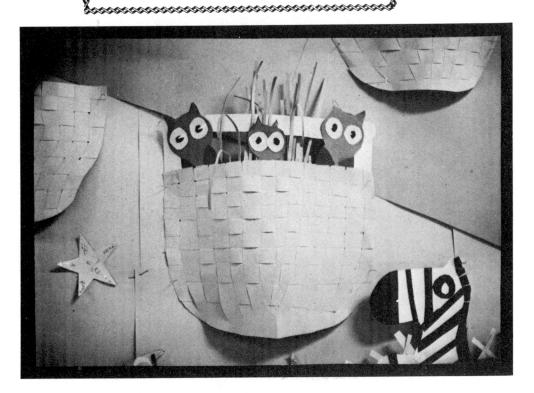

This is basically a weaving lesson, but it is made more interesting by using a basket shape instead of the usual mat. Therefore it appeals to a wider range of age groups.

PREPARATION Make an example of the project before presenting it to the class. Fold two 12" x 18" pieces of yellow paper lengthwise, one on top of the other, and draw the outline of a basket shape plus a lid, as in Figure 6-5a.

Cut the pieces out and lay one set aside (one basket and one lid). Keep the other set folded and make vertical cuts from the top toward the bottom of the basket shape. Stop within an inch of the lower edge, then repeat the process on the lid. (See Figure 6-5b.)

The cuts should repeat the curved contours of the outside edge and become almost straight as you approach the center fold. Put these aside and work with the other set. These two pieces are to be cut into horizontal strips, and this time you will cut them all the way across. Unfold each strip as you cut it off, then place it in an orderly consecutive arrangement so that the basket shape is retained. (See Figure 6-5c.)

Unfold the first vertically cut set and lay it alongside the horizontal one. Discard the bottom horizontal strip, and beginning with the next strip up, weave it through the verticals. After all the strips are woven and

FIGURE 6-5a

tightened closely together, secure the last one across the top with strategically placed dots of glue. Finish the lid the same way.

FIGURE 6-5b

FIGURE 6-5c

PRESENTATION Display your basket and lid for the class and tell them that this construction is only the first part of the project, and that their baskets are to have something surprising in them. So that the contents may be seen, the lid will have to be set at an angle or even considerably raised up above the basket as if the contents were pushing out. Students may plan to make just about anything under the sun to be

contained in the baskets. The only requirement is that the subject be interesting, pleasing, and/or funny to look at. Birds, fish, animals, or people, scaled to fit the shape of the container, can all be considered as possibilities. After the subjects have been decided upon, the color for each basket and its shape can be determined individually.

DISPLAY Back a large bulletin board with alternating colors of construction paper placed to create the effect of giant stripes. Push straight pins through the side edges of each basket and into the board backing. Allow the baskets to bulge outward slightly, as you are securing them, and then place inside each whatever is supposed to be there. Clusters of shiny stars or colored flowers scattered between baskets create an attractive "finished" look to the display.

Variations

I

Instead of filling the baskets with surprises, fill them with flowers. Omit the lid, but replace it with a sturdy, double-thick handle. Make long, long paper chains to match the basket colors, then hang them from the ceiling just before the first of May. (See Figure 6-5d.)

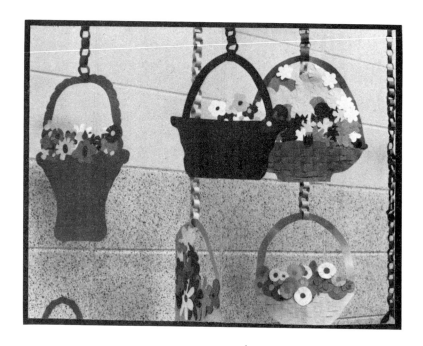

FIGURE 6-5d

II

Make all the baskets yellow and fill them with trailing green plants rather than flowers. Then hang them in a tiered arrangement—two or three to a chain. The giant flowers from Chapter 2, lesson 4 make a harmonious wall companion display. (See Figures 6-5e and 6-5f.)

FIGURE 6-5e

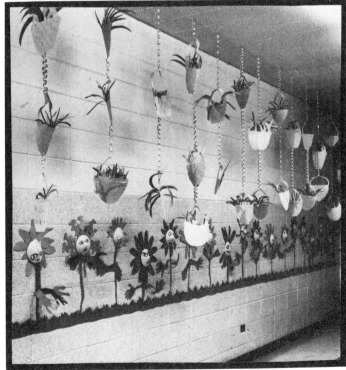

FIGURE 6-5f

III

Fold a standard rectangular weaving-mat, add flowers, and hang as before. (See Figures 6-5g and 6-5h.)

FIGURE 6-5g

FIGURE 6-5h

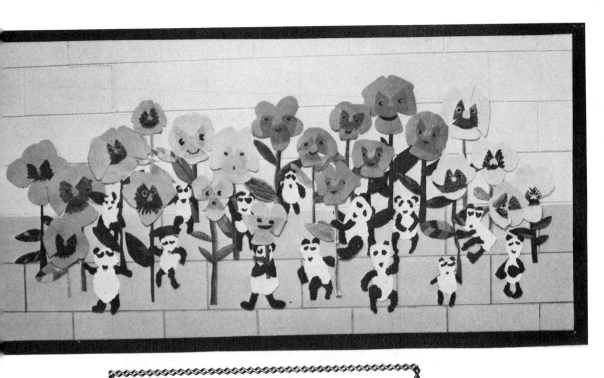

LESSON 6

Pansies and Pandas

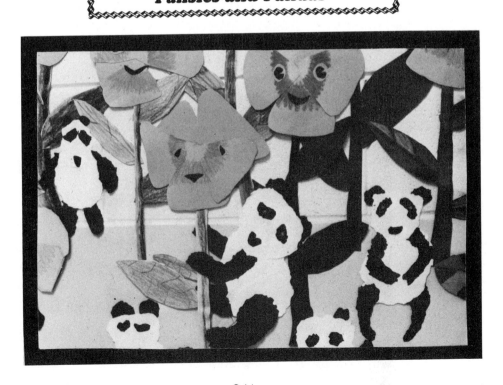

PREPARATION Make an example of a giant pansy and small panda to facilitate the presentation of this project. Create the flower first.

On a 12″ x 18″ piece of yellow paper draw three large petals and two smaller ones, as in Figure 6-6a.

FIGURE 6-6a

Using a yellow crayon, color heavily the inner portions of the three large petals. Switch to a brown crayon and add this color to the middle portions of the same petals (see Figure 6-6b).

FIGURE 6-6b

From a small folded piece of black paper, cut out two circles the size of a quarter and remove a wedge from each. These will be the eyes. Glue them to unused portions of the yellow paper, then cut them out again so that the yellow surrounds the black. Set these aside for a moment and fashion a mouth from the remaining scraps of black.

Cut out the flower petals and assemble the three large ones first, then arrange the two smaller ones behind them. (See Figure 6-6c.)

FIGURE 6-6c

Glue on the eyes and mouth after first experimenting with their placement.

Draw a slightly curving stem the length of a 12″ x 18″ piece of green paper, then add three leaves alternately along the stem. Apply three shades of green crayon (heavily) to these and do it before you cut them out; otherwise the paper might tear.

After the flower is assembled, take a sheet of 9″ x 12″ white construction paper and begin on the panda. These shapes are to be torn out, rather than cut, to provide a fuzzy-edged texture. You can draw a light pencil outline before beginning if you would feel more confident with that, but you may be surprised at how accurately you can control the emerging form without scissors. Tear head, body, and nose projection from white. The head is roughly the same size and shape as one of the large pansy petals (see Figure 6-6d).

Fold a piece of 9″ x 12″ black paper and tear out two forelegs, two backlegs, ears, and eyes, as in Figure 6-6e.

FIGURE 6-6d

FIGURE 6-6e

Assemble the bear's body with masking tape rather than glue. This is to allow you to take it apart during presentation and reassemble as you are demonstrating for the class various possible combinations of arm and leg positions. Ears, eyes, and nose can be glued on the face at this time. The nose tip (so that it's shiny) is cut from a scrap of a black plastic bag. This, in turn, is glued to the lower portion of the small white nose-oval and attached to the middle of the face at one end only. The lower end (with the black plastic) can be pulled out so that it is raised a

bit from the face and adds some dimension. The slight shadow cast by this piece creates the illusion of a mouth. The eyes are made shiny by squirting a circle of glue in the centers and then allowing that to harden for several hours.

PRESENTATION Pin up the pansy for your class to see. Several children might be familiar with this flower and will know that although the real ones are much much smaller, they do appear to have faces. Explain that the faces to be made for these pansies are exaggerated so that an entertaining resemblance may be seen in the panda faces. Display the panda in conjunction with the flower and show a variety of poses such as holding the flower in the forepaws, climbing the flower, hanging from a leaf, etc. This demonstration will capture each child's imagination and become a project planning aid.

Begin to make the pansies by offering a choice of colors for the petals: yellow, pink, orange, and lavender 12" x 18" construction paper should be made available. Flower construction is exactly the same as described earlier with the exception of the crayon color. Brown crayon will be used with the yellow paper as before; pink paper needs lavender crayon; orange paper needs dark orange, and lavender paper should have violet. If you can, offer two different shades of green paper for the stem leaf construction. Keep the flowers on the desks so that panda poses may be coordinated during their stages of development.

DISPLAY Put up the flowers first in their color groups. Working from left to right, begin with the lavender flowers. Next place the pink group, then the orange, and end with yellow on the extreme right side of the display. Coordinate the panda placement with the flowers. Some overlapping will be necessary; just be sure none of the faces are hidden.

Variation

The large pansy faces can be used to decorate the fronts of work folders. Lying on top of students' desks, they produce a bright, welcoming sight for Open House.

Index

247